IMAGES
of America

ALONG THE
TUOLUMNE RIVER

ON THE COVER: The history of the Tuolumne River is the story of many unique towns and cities. The taming of the river allowed irrigation to develop throughout the region. In this c. 1940 image, men are irrigating an orchard near Turlock. Today, the land is irrigated using water from the Tuolumne River watershed, and it is important to recognize the river's role in the area's history. (Courtesy of the McHenry Museum.)

IMAGES
of America

ALONG THE
TUOLUMNE RIVER

Brandon Guzman and Miguel Velazquez

ARCADIA
PUBLISHING

Published by Arcadia Publishing
Charleston, South Carolina

Printed in the United States of America

Library of Congress Control Number: 2014947946

For all general information, please contact Arcadia Publishing:
Telephone 843-853-2070
Fax 843-853-0044
E-mail sales@arcadiapublishing.com
For customer service and orders:
Toll-Free 1-888-313-2665

Visit us on the Internet at www.arcadiapublishing.com

*To our parents, who gave us everything we needed to succeed
(even though we did not go into the field of science)*

CONTENTS

ACKNOWLEDGMENTS

This book could not have been completed without the support of the collections that offered images to us. The McHenry Museum and Historical Society; California State University Stanislaus Special Collections Library; Carlo M. De Ferrari Archive of the Tuolumne County Library; Alexander Trujillo; Robin Yanez, of Sacred Heart Parish in Turlock, California; the Souza family; Hughson Museum and Historical Society; Great Valley Museum of Natural History; Waterford Museum and Historical Society; and the La Grange Museum gift shop provided photographs and research directions for our project.

It is important to recognize and give appreciation to Laura Mesa, Kenneth Potts, and Charles Dyer for their research support and archival work. To our acquisitions editor, Ginny Rasmussen: you provided advice and ideas that were necessary for finishing the project—thank you. It is also important to recognize Katie Reid for her work in helping us promote the book.

The authors would like to also thank Maurice Hippmann for technical support and Eric Nystrom for taking his time to assist with editing the project. Finally, it is important to acknowledge the hardworking individuals who made Stanislaus County what it is today. To the dreamers, risk-takers, and mothers: you made it all possible.

INTRODUCTION

Go West, young man, go West and grow up with the country.

—Horace Greeley (attributed)

The Tuolumne River provides life to an entire region in the Central Valley of California, playing a role in Stanislaus County mainly through irrigation. *Along the Tuolumne River* was researched and composed to put an emphasis on the river's importance in the area's economy and how it has been the central variable in historical commercial development. The first chapter, "Natural History of the River," offers a look at where river was and is today. The chapter will also discuss the importance of the river's natural ecosystem.

The second chapter, " The Hetch Hetchy Project," looks at the O'Shaughnessy Dam, which was built in the upper Tuolumne River. The damming of the Tuolumne River at this strategic location in the Hetch Hetchy Valley drew controversy not only at the state and local levels, but also at a national level. Hetch Hetchy is located in Yosemite National Park, and John Muir was one of the greatest opponents of the dam. However, his ideological battle was lost due to the necessity of water in San Francisco.

The third chapter, "Development of Irrigation," chronicles the many dam projects built along the river. Irrigation has been practiced by many civilizations throughout history, and Stanislaus County is no exception. The region was fortunate that the Tuolumne River flows through its territory. The right to privatize the water of the river was passed with the Wright Law in 1887. The Turlock Irrigation District and the Modesto Irrigation District have worked together to build the irrigation projects that now exist in the county. The dams provided not only water but also electricity to a plethora of families throughout the years.

California is known worldwide for its agricultural products. Stanislaus County is located in the heartland of California and is one of the state's most important producers. Chapter four, "Agriculture along the River," is a shortened visual history of Stanislaus County agriculture. The soil of Stanislaus County has been used for agricultural pursuits for more than 100 years. Cattle ranchers had success thanks to the thousands of acres of grasslands for the cattle to graze. Wheat farming was profitable to the first men who immigrated to the county, but drought years concerned the farmers. Then, irrigation gave them the security for their crops, and area farmers introduced many fruit trees and vegetables to the county. Watermelons were a big hit for farmers around the Turlock area. Alfalfa was the leading crop in the first irrigated farms. This helped secure the growth of the dairy industry, which is still found throughout the county. The most profitable crop in the county has been almonds. To protect the growing industries, residents created Granges and co-ops to promote local industries.

The fifth chapter, "Town Development," focuses on how Modesto and Turlock expanded because of the changing agriculture throughout the county's history. This chapter features most of the

settlements, towns, and cities that benefitted from the Tuolumne River. The earliest settlements were established near the river, but as irrigation developed, towns began moving farther away. Locals still depended on the river, but thanks to canals, it became less important to live so close. As Stanislaus County grew, Modesto and Turlock became important hubs for business. The labor immigration that came during the harvest season helped the towns grow. A few groups that immigrated to the area included the Japanese, English, Mexicans, Chinese, Swedish, Germans, Assyrians, Portuguese, and so many more. They built churches, schools, and businesses that added to the development of the county.

The Tuolumne River has brought wealth to Stanislaus County, and it also offers outdoor enjoyment for everyone. The sixth and final chapter, "Recreation on the River," is devoted to those who take advantage of the natural attributes of the river. Many fun and educational activities can be practiced along and in the Tuolumne River, including fishing, swimming, and boating.

The Tuolumne River has played an influential role in developing the region. The river is a source of life for the environment and for the many towns and cities that surround it. Our forms of agriculture would not be possible without the taming of the river. Some residents of the United States put an emphasis on protecting business interests around the world but hardly take the time to understand what is around them right here at home. Local resources are the most important resources; the river is our history, and we must protect it.

One

NATURAL HISTORY OF THE RIVER

The Tuolumne River is located in the central-eastern part of California. The river flows for 150 miles, from the Sierra Nevada Mountains to the San Joaquin River, and through three counties—Mariposa County, Tuolumne County, and, finally, Stanislaus County. The river does have set boundaries today, but prior to water management, it would flood every year into the lowlands of Stanislaus County. (Courtesy of CSU Stanislaus Special Collections.)

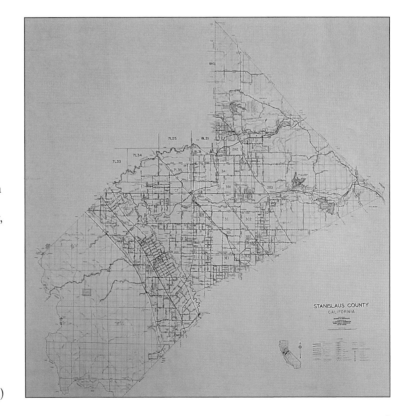

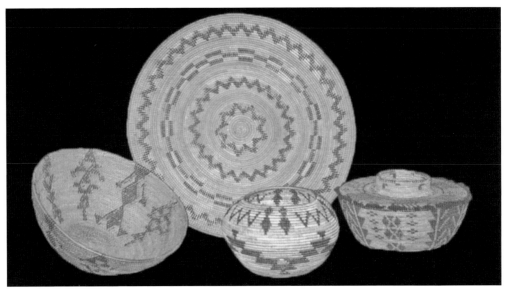

It is difficult to say which native group arrived in the region first, but the Miwok have been living in the Tuolumne River area for over 2,000 years. The Eastern Miwok lived primarily in the upper portion of the Tuolumne River. During the Gold Rush in the 1850s, the Miwok had to move to avoid contact with the new immigrants. This image shows examples of traditional Miwok basketry. (Courtesy of the Great Valley Museum.)

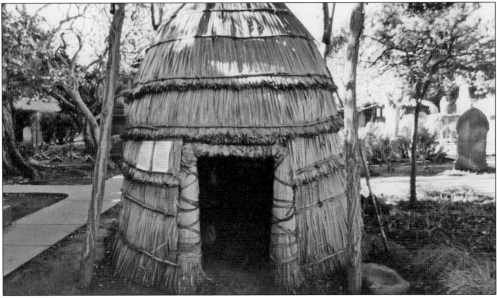

The Yokuts controlled the land around the San Joaquin River and many of its tributaries. The Northern Valley Yokuts lived along the lower half of the Tuolumne River. They were even able to use the river for transportation using canoes made of tule reeds. The Yokut numbers were in the thousands, but by the mid-19th century, few of them were left in the area. European diseases introduced during the Spanish mission period moved along trading routes and infected thousands. The Yokuts are known worldwide for their baskets, which were made out of grasses and other organic materials. This image is of a traditional Yokut tule house that would have been found near the river. (Courtesy of the authors.)

The freshwater biome developed by the Tuolumne River is known biologically as a riparian woodland. The riparian habitat is known for hosting a great diversity of plant and animal species. In the Central Valley, the riparian woodland is easily identifiable from the air in the summertime. Even when all the grasses in the valley have gone brown, the river's ecosystem is still green when viewed from an airplane. (Courtesy of the authors.)

The Central Valley was once 95 percent covered in grasslands but is now 95 developed for housing. The grasses had roots—sometimes more than 100 feet long—that ran deep enough to reach the water table during drought years. The grasses typically seen in the area now are mostly imported. Today, less than one percent of the original grasslands exist in the Central Valley. (Courtesy of the authors.)

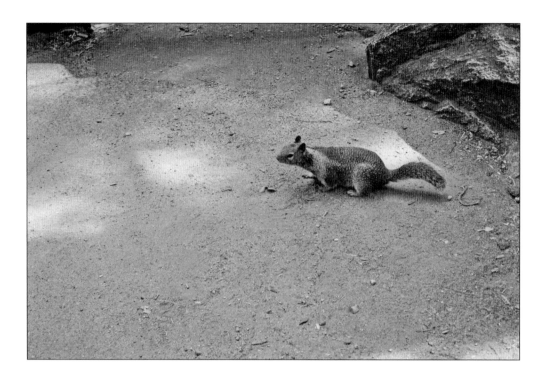

The Tuolumne River is the main source of water for the area, so mammals generally live close to the river. The riverbank is home to a plethora of mammal species, including mountain lions, beavers, muskrats, river otters, raccoons, opossums, rats, skunks, and more. The above image shows a western gray squirrel, which is most commonly found high up in the oak trees along the river. The below image shows a black bear interacting with some campers in the Hetch Hetchy Valley. (Above, courtesy of the authors; below, courtesy of Carlo M. De Ferrari Archive.)

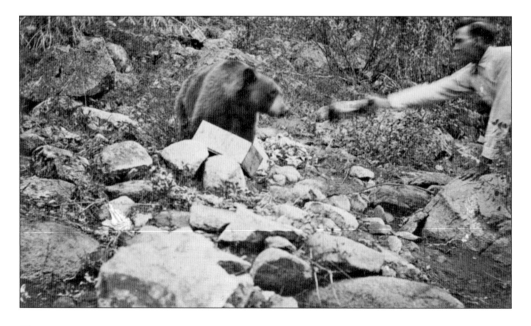

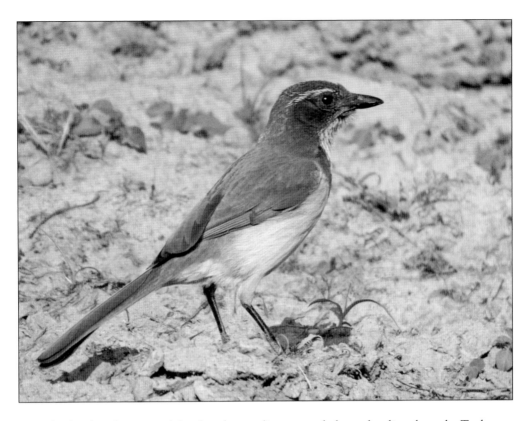

Many birds take advantage of the abundance of insects and plants that live along the Tuolumne River. Above is the western scrub jay, one of the smartest birds along the river. It is often mistaken for the blue jay, which is found in the eastern part of the United States. The image below shows ducks in a pond near Ceres, California. California is known for being one of the major waterfowl flyways of the American West. (Both, courtesy of the authors.)

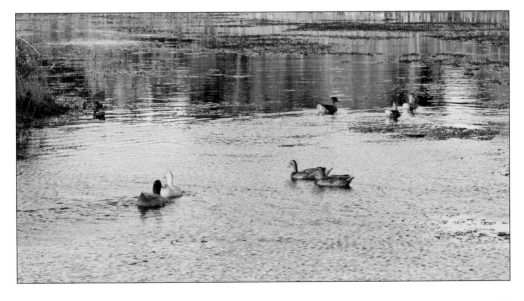

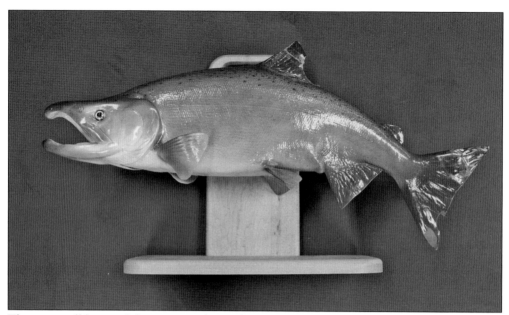

The most well-known fish species in the Tuolumne River is the chinook salmon. The chinook are anadromous fish, so they spend most of their life in salt water but spawn in freshwater rivers and streams. Fishing is only allowed in the Tuolumne River during the winter, spring, and summer months, because the salmon spawn in the fall. Water control has affected the spawning capacity of the river, and wildlife workers have noticed a drop in salmon populations. Thanks to conservationists, the salmon have been able to continue using the Tuolumne River as a spawning location. The above image shows a mounted salmon, while the image below is of a salmon that had spawned and died in the Tuolumne River. (Both, courtesy of the Great Valley Museum.)

California is known for its natural beauty and wonders. One of the most spectacular trees in California is the *Quercus lobata*, known commonly as the valley oak. These trees once blanketed the hills and a good portion of the valley floor. Many trees have been able to reach over 100 feet in height. The oak trees are known in anthropology for providing the California indigenous peoples with acorns. Acorns were the dietary staple for the Yokuts and Miwok in the Tuolumne River area. The image below shows the galls that develop on the oak trees when wasps lay their eggs on the bark and leaves. (Both, courtesy of the authors.)

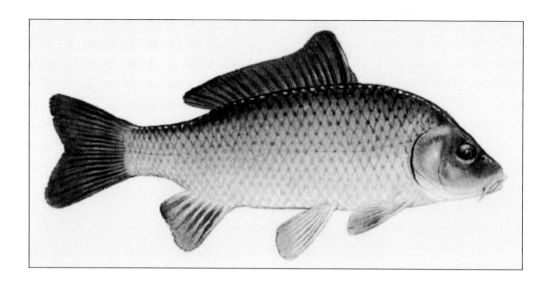

The Tuolumne River ecosystem has changed drastically over the last 200 years. After the arrival of white settlers, diseases spread and killed many of the indigenous people. One of the most invasive introduced fish species is the common carp. It has been taking the space of native species in the ecosystem and eating the eggs of other fish, such as the chinook salmon. A second introduced species that has affected the riparian environment is the water hyacinth. The plants stop sunlight from reaching the native submerged plants, sucking out the oxygen and slowing down the flow of water along the river. In the below image, the water hyacinth is partially dead after being sprayed with herbicide. (Both, courtesy of the authors.)

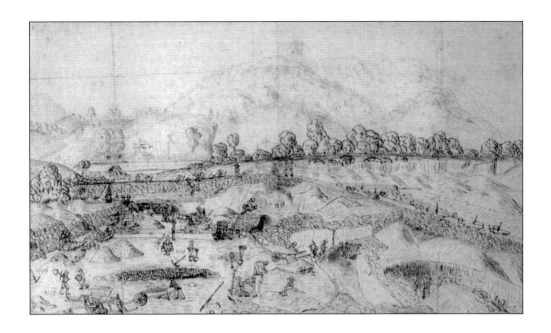

The indigenous people of the area always knew gold existed in the mountains, but they never used it as a major form of currency. In 1848, gold was discovered by white settlers near the American River, and from that point, the world got gold fever. Immigrants came from everywhere to search for gold. The Tuolumne River received its share of prospectors who came to mine. The above image is a sketch from the 1850s of a mining camp along the Tuolumne River. The image below is a 19th-century photograph of miners working a sluice. (Above, courtesy of Carlo M. De Ferrari Archive; below, courtesy of the McHenry Museum.)

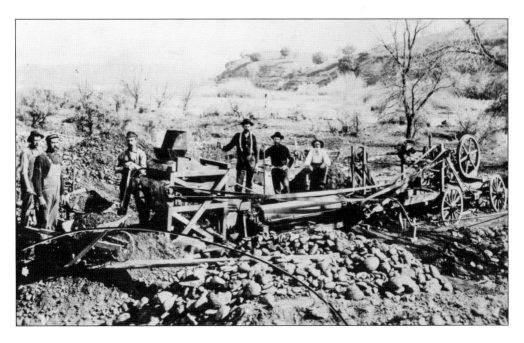

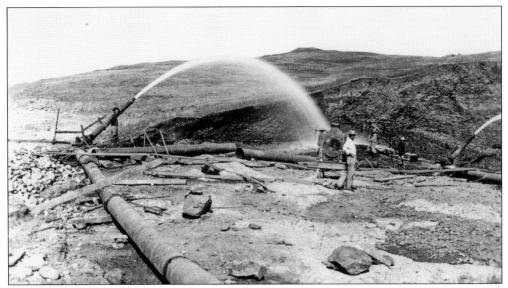

The gold that was easy to find on the surface was picked up out of the Tuolumne River during the 19th century. The above photograph depicts an early advancement known as hydraulic mining, one of the numerous technological advancements that allowed for higher productivity. The below image is of a mining dredger in La Grange. The mining dredger was in operation from 1933 until the mid-1950s. The dredgers were only profitable because of their size and the amount of "pay dirt" that could be sorted in a single day. (Above, courtesy of the McHenry Museum; below, courtesy of CSU Stanislaus Special Collections.)

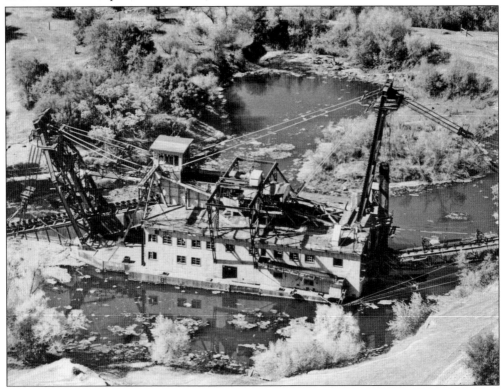

Two

THE HETCH HETCHY PROJECT

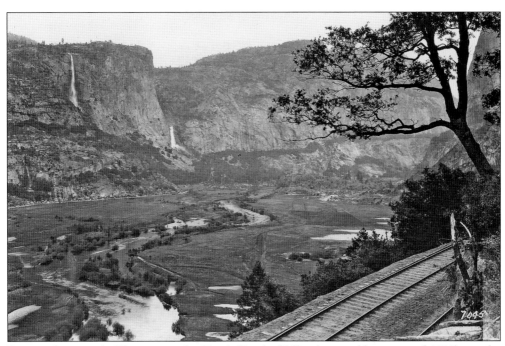

Prior to the arrival of Europeans, the Hetch Hetchy Valley (pictured here around 1908) was the home of a plethora of flora and fauna. Indigenous groups, such as the Miwok, made use of the valley floor as a summer home. The Tuolumne River at the base of the valley provided Indians with fish as a major food staple. Hetch Hetchy was considered by many to be the most beautiful scenery in the California Sierras—even more so than Yosemite Valley. (Courtesy of Carlo M. De Ferrari Archive.)

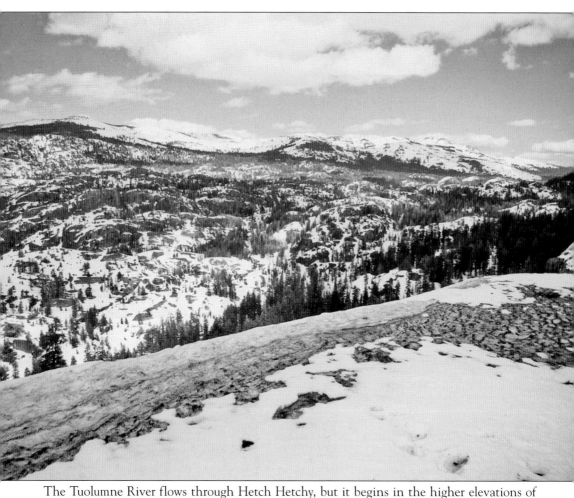

The Tuolumne River flows through Hetch Hetchy, but it begins in the higher elevations of Yosemite National Park. Many streams flow into the Tuolumne River from the snowpacks east of the Yosemite Valley. (Courtesy of Gary Hayes.)

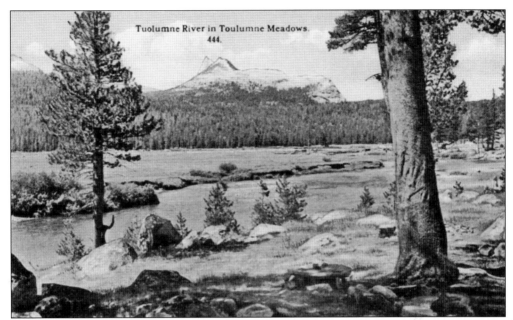

Tuolumne River in Tuolumne Meadows.
444.

The Tuolumne Meadows is an area located east of the Yosemite Valley that is known worldwide. Wildlife is abundant in this beautiful region. Although the meadows are often left out of the popular conception of Yosemite, they are always full of green in the early months of the year. Because it is located at an elevation of over 8,000 feet, this beautiful scenery is covered in snow during the winter months. (Courtesy of Carlo M. De Ferrari Archive.)

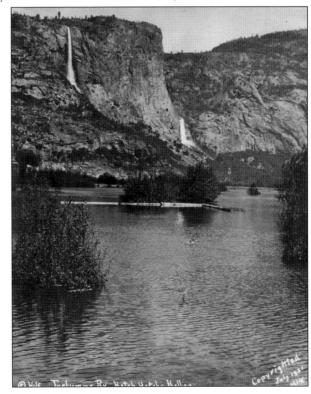

The Tuolumne River flowed through the center of the valley. Like the Yosemite Valley, the Hetch Hetchy Valley has its own collection of spectacular waterfalls. This viewpoint shows Tueeulala Falls, at left, which are close to 880 feet tall. Wapama Falls, on the right, drops three times and is 1,080 feet tall. (Courtesy of Carlo M. De Ferrari Archive.)

21

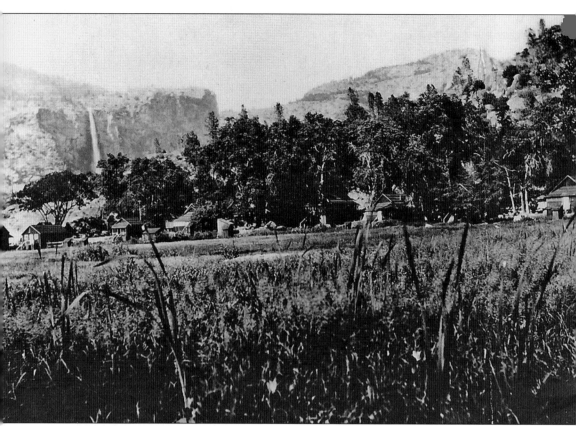

The damming of Hetch Hetchy Valley did not just take away its natural beauty, it also took away people's homes. People made their homes in the valley because they could live off of the rich resources provided by the valley. This image shows homes in the valley; note the amazing view they had of the waterfall in the background. (Courtesy of Carlo M. De Ferrari Archive.)

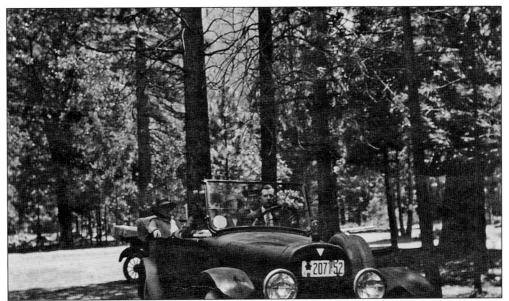

Hetch Hetchy is located in the northern portion of Yosemite National Park. Because of its unique beauty, tourists would travel to see its waterfalls. By the 1930s, state and federal authorities had developed roads to allow travelers to come to Hetch Hetchy by automobile. This image shows a group driving through the park. Even today, millions of people from all over the world visit the park each year. (Courtesy of Carlo M. De Ferrari Archive.)

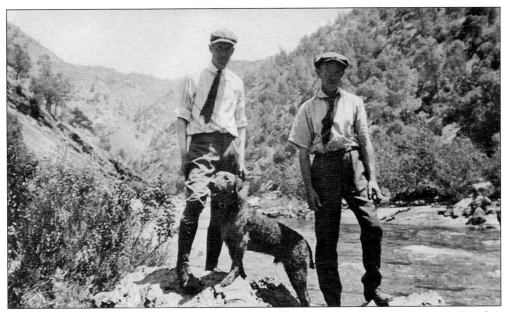

In the early part of the 20th century, the Hetch Hetchy Valley was as a tourist hot spot. Families would drive up from the Central Valley to spend weekends or even summers amidst the beautiful scenery. The identities of the two men in this image are not known, but for many, hiking along the Tuolumne River was a favorite distraction from everyday life. (Courtesy of Carlo M. De Ferrari Archive.)

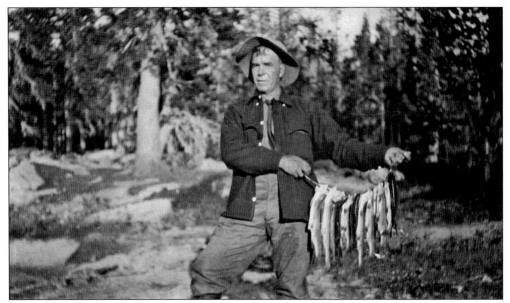

Hetch Hetchy is higher in elevation than the Central Valley, so different fish species are found in the Hetch Hetchy portion of the river. The man in this photograph is holding a day's catch of trout caught in the Tuolumne River. Fishing in the area is still a common activity for both locals and tourists. (Courtesy of Carlo M. De Ferrari Archive.)

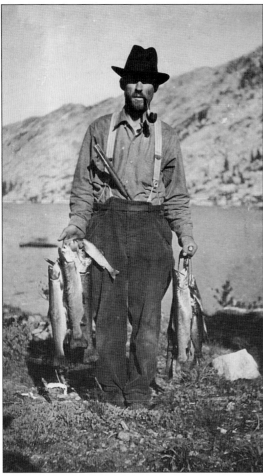

The Tuolumne River had many fish swimming along its course. During the construction of the dams, workers were able to fish the Tuolumne and use its resources. The fish were used to provide people with a source of nourishment, and now fishing has become a recreational sport in the Hetch Hetchy Reservoir. Judging from pictures like this, it is evident that the fishing trips were bountiful. (Courtesy of Carlo M. De Ferrari Archive.)

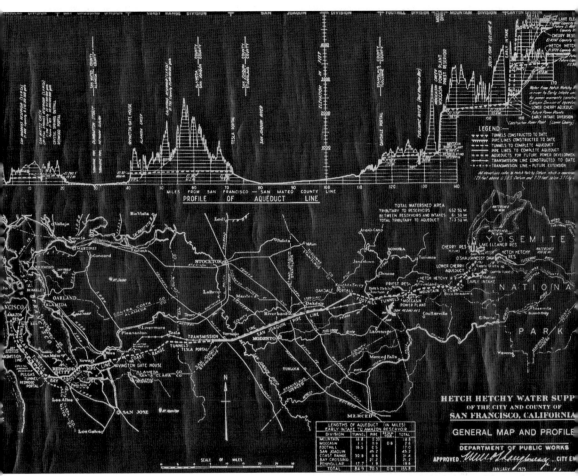

In 1906, San Francisco was hit by a major earthquake that started a fire that could not be contained by its current water supply at the time. The Hetch Hetchy water project was devised to move water over a distance of 150 miles. As indicated by the plans shown here, the pipeline was designed to make a general downward slope. The pipe was built aboveground, then descended into a tunnel west of Modesto. This map was created in January 1925. (Courtesy of Carlo M. De Ferrari Archive.)

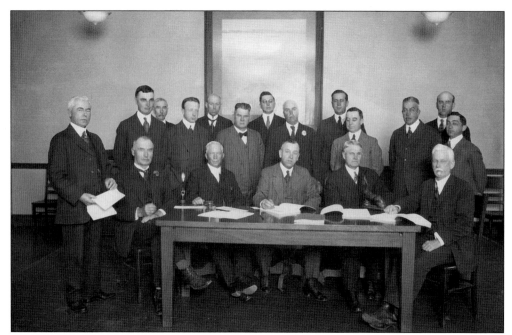

The Hetch Hetchy water project began on August 12, 1919. The most important person in this photograph is Irish civil engineer Michael M. O'Shaughnessy (seated, far left); he was hired by the City of San Francisco to develop the entire Hetch Hetchy water project. O'Shaughnessy designed the dam, and it was named in his honor. (Courtesy of Carlo M. De Ferrari Archive.)

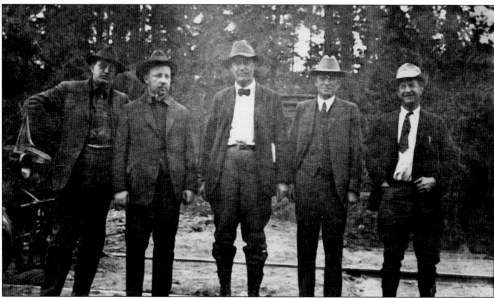

These men, pictured in 1920, were heavily involved in designing the dam, the railroad, and the aqueducts for the Hetch Hetchy projects. They are, from left to right, Nelson Eckhart, a City of San Francisco employee hired to design the aqueducts; Carl Rankin, the head engineer for the Hetch Hetchy Railroad, which delivered materials for the O'Shaughnessy Dam; Charlie Tinkler and Al Clearly, professional partners in engineering the many tunnels for the Hetch Hetchy water project; and ? Phillips, a construction colleague. (Courtesy of Carlo M. De Ferrari Archive.)

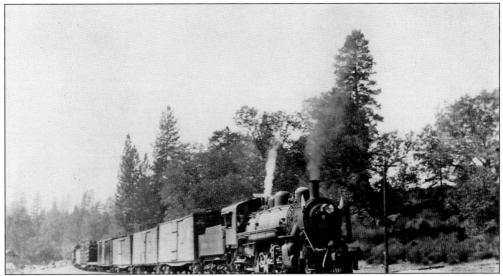

The City of San Francisco built the Hetch Hetchy Railroad in 1912 as a branch off of the Sierra Railway at Tuolumne City. The city built the railroad because, in the winter months, it was more reliable than trucks driving through the mountains. Because of the terrain, constructing a railroad was also more cost-efficient than building a road. Carl R. Rankin, a Southern Pacific engineer, designed the railroad's route through Hetch Hetchy Valley. (Courtesy of Carlo M. De Ferrari Archive.)

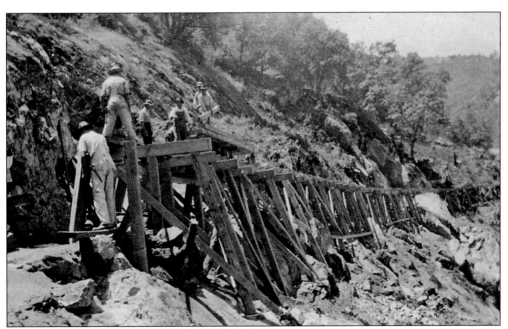

The terrain of the Hetch Hetchy project was considered the rockiest of the early California dams. The workers pictured here are building a set of railroad tracks to the construction site. They worked for years in the mountains, without the assistance of modern machinery, and had to destroy the natural landscape to develop the mountainsides. (Courtesy of Carlo M. De Ferrari Archive.)

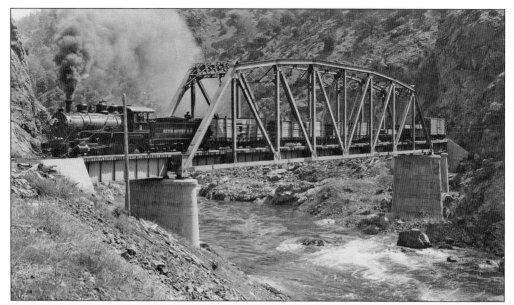

Hetch Hetchy tourists once had to take a steamer, then ride a horse up into the mountains, but that ended with the construction of the Hetch Hetchy Railroad. What was once a weeklong trip was cut down to a couple of days. The railroad became the same supply line that dammed up the valley and increased tourism to the valley. (Courtesy of Carlo M. De Ferrari Archive.)

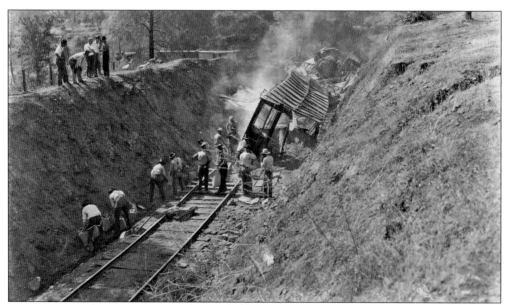

The Hetch Hetchy Railroad did not have many major accidents, but when brake systems failed in the mountains, it usually did not end well. On September 13, 1922, Engine No. 4 crashed after its air brakes failed, and it derailed. In this image, men are trying to shovel cement into bags so that everything was not lost. Because the route was so important in delivering supplies to the dam project, this cleanup took place in only one day. Many sacrifices were made to accomplish the transformation of the Hetch Hetchy Valley. (Courtesy of Carlo M. De Ferrari Archive.)

The O'Shaughnessy Dam was a major project that required an army of manual labor. The dam site was located high in the mountains, and it was troublesome to move heavy machinery into the region. Preliminary work on the dam required laborers to alter the landscape while preparing the location for construction. Concrete was the primary building material used to construct the dam. (Courtesy of Carlo M. De Ferrari Archive.)

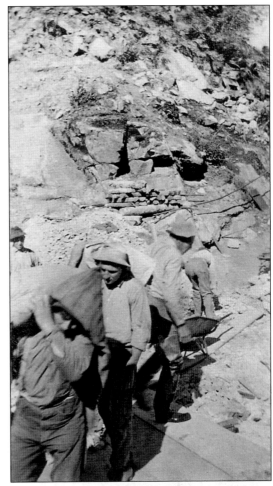

Those who worked on the O'Shaughnessy Dam came from all over the area. The dam may have been built by men, but it required support from their families. Women stayed in the camps while the men worked on the dam. Like the pioneers, these families had to move to an area they were not familiar with. This City of San Francisco–funded construction project tried to make workers feel as comfortable as they could, even building churches in the area to allow a regular routine for the families. (Courtesy of Carlo M. De Ferrari Archive.)

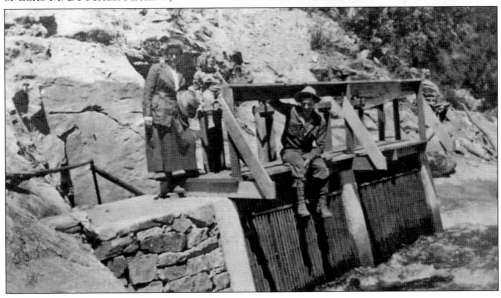

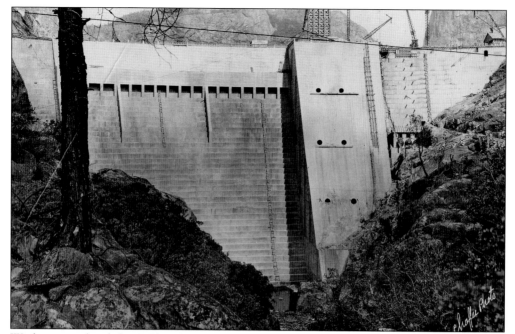

Workers completed the O'Shaughnessy Dam in May 1923. As shown in this 1920s image, the canyon provided an excellent location for damming the river. The dam took more than three years to complete, and it provided jobs for those living in the Sierras. Being able to control the river at its source allowed for future dams to be constructed downstream without too much flooding. (Courtesy of Carlo M. De Ferrari Archive.)

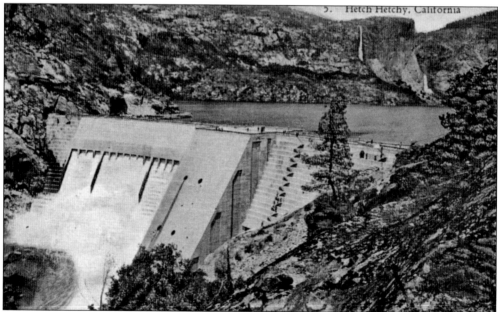

This postcard shows the completed and fully functional O'Shaughnessy Dam. As early as the 1920s, guests in the Yosemite Valley would make side trips to see the spectacular engineering feat. The majority of these guests were citizens of San Francisco and Oakland who wanted to see where and how their tax money was being spent. (Courtesy of Carlo M. De Ferrari Archive.)

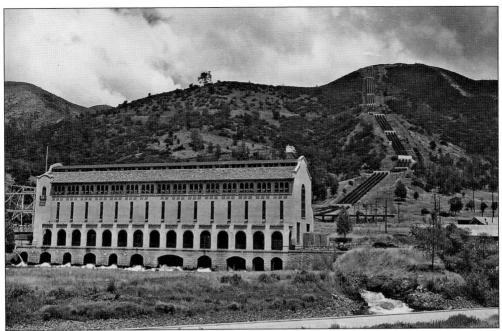

The O'Shaughnessy Dam was built so high up in the mountains that it made sense to build a powerhouse and take advantage of "modern" hydroelectric technology. The Moccasin Powerhouse was constructed to provide electricity to local communities and towns. The Raker Act of 1913 eradicated the protected status of the Tuolumne River and allowed construction of the dam. These major projects provided greater opportunities for the future development of local communities. (Courtesy of Carlo M. De Ferrari Archive.)

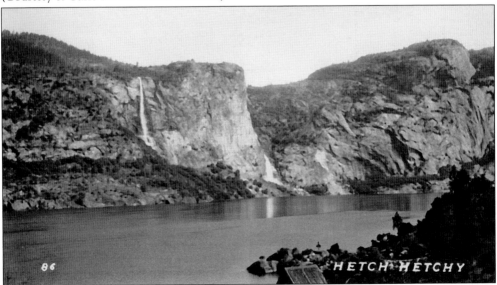

The Hetch Hetchy Reservoir was the end result of the O'Shaughnessy Dam project. Under the direction of the well-known naturalist John Muir, the Sierra Club made efforts to protect the valley. Unfortunately, the City of San Francisco had the political means to purchase the water rights in the area. The valley is no longer a landscape of beautiful grasses but a man-made engineering spectacle. (Courtesy of Carlo M. De Ferrari Archive.)

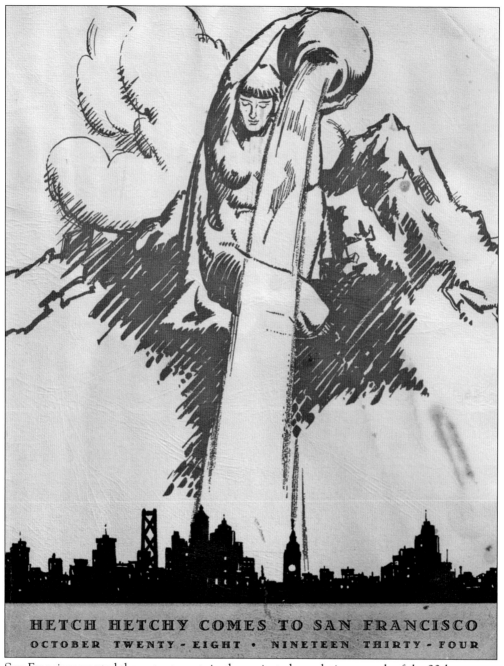

HETCH HETCHY COMES TO SAN FRANCISCO
OCTOBER TWENTY - EIGHT • NINETEEN THIRTY - FOUR

San Francisco wanted the water to sustain the projected population growth of the 20th century. This is the cover of a pamphlet printed for the celebration of the Hetch Hetchy water coming to San Francisco. As suggested by the image, the damming of Hetch Hetchy was equivalent to Mother Nature giving life to the future of San Francisco. (Courtesy of Carlo M. De Ferrari Archive.)

Three

DEVELOPMENT OF
IRRIGATION

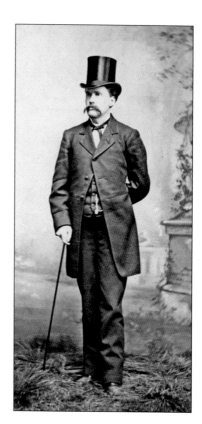

C.C. Wright came to California from Iowa at an early age and moved to La Grange to teach at one of the area schoolhouses. He passed the bar exam and began to practice law in Modesto. In 1886, he was elected to the California Assembly with the intention of developing irrigation legislature. The Wright Act, passed in 1887, legalized public ownership of the irrigation projects throughout the state of California. The law essentially allowed the people to develop and build what they needed to control the water. The county and the state may have developed differently without the guidance of Wright. (Courtesy of the McHenry Museum.)

Today, dams and canals are the arteries that give life to the agriculture of Stanislaus County. The county grew the most after it was given the opportunity to flood its fields. But irrigation was not favored by everyone—some farmers were so strongly against it that they developed political parties in an effort to stop irrigation development. The images on this page depict an average wheat farm. The wheat farmers controlled the county's economy, which in turn gave them control over the region. If irrigation was installed, immigrants and laborers would be able to maintain their own small farms and not be reliant on the larger wheat farms. (Both, courtesy of the Hughson Museum.)

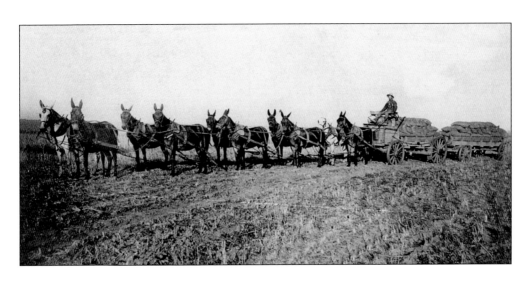

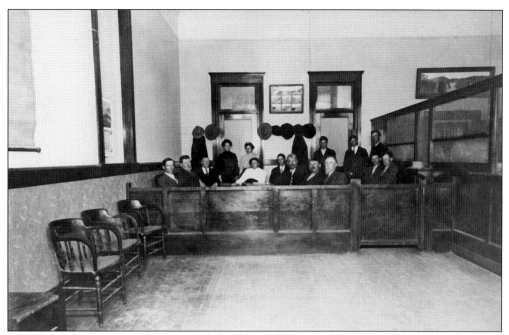

The Tuolumne Water Company was the first organized water control project in Stanislaus County. It was mainly owned by San Francisco businessman M.A. Wheaton. The Turlock Irrigation District (TID), organized in June 1887, was the first irrigation district established under the Wright Act. The first TID office was located in Ceres until 1910, when it was moved to Turlock. The c. 1912 image above offers an inside view of the Turlock Irrigation District building. The image below is of the new and modern TID headquarters. (Above, courtesy of CSU Stanislaus Special Collections; below, courtesy of the authors.)

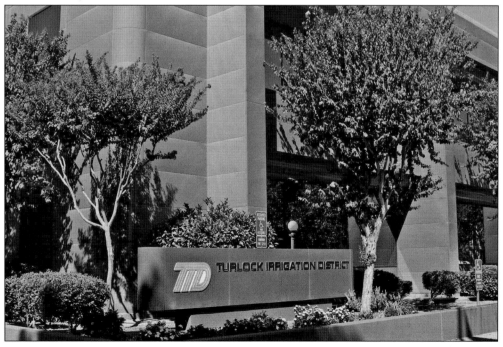

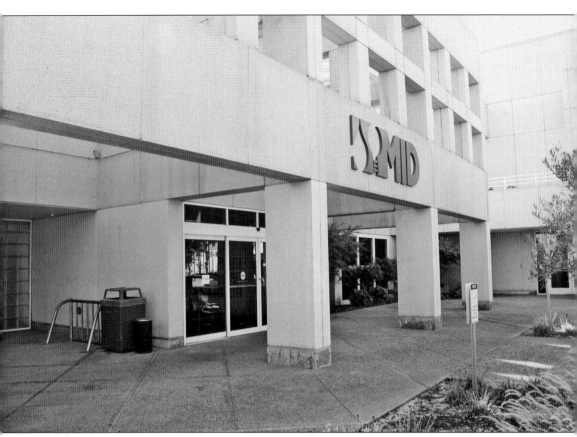

This is the modern Modesto Irrigation District (MID) building. MID was founded in July 1887, one month after the Turlock Irrigation District. MID not only specializes in irrigation water, it also operates a water treatment plant that provides drinking water to the city of Modesto. It is important to note that MID merged with the Waterford Irrigation District in 1978; this allowed MID to have complete control over the northern banks of the Tuolumne River. MID irrigates nearly 60,000 acres of farmland each year. (Courtesy of the authors.)

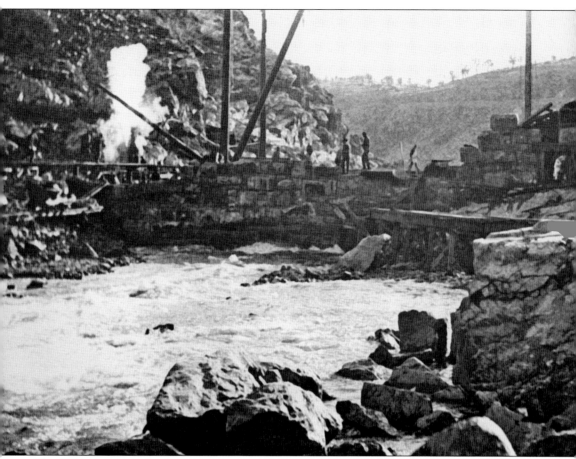

The Wheaton Dam, the first dam constructed in Stanislaus County, went up in 1852. It was first used for mining purposes and later converted by M.A. Wheaton for irrigation use. This location was eventually used for the construction of the La Grange Dam, which is pictured here around 1891. The La Grange Dam, a joint effort between the Turlock Irrigation District and the Modesto Irrigation District, was completed in 1893. (Courtesy of the McHenry Museum.)

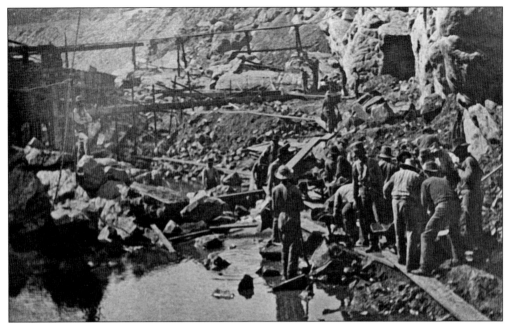

The La Grange Dam was made of rough stone set in concrete mortar. Men only worked on the dam during months of low water flow. The dam was completed at a total height of 130 feet. "At its completion, the La Grange Dam, as it became known in irrigation literature, was one of the most notable structures of its kind in the world," according to historian Sol P. Elias in his *Stories of Stanislaus*. When the dam was constructed, it was the tallest overflow dam in the world. The c. 1892 photograph above offers great insight into the hard labor put into the project. The image below shows what the dam looked like when it was completed in 1893. (Both, courtesy of the McHenry Museum.)

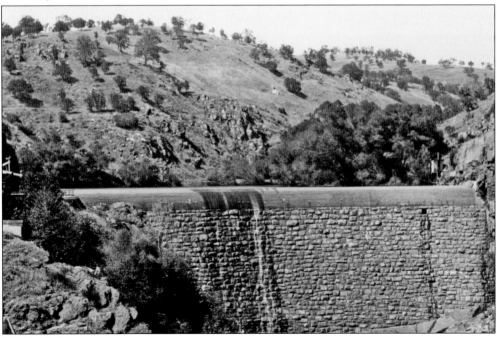

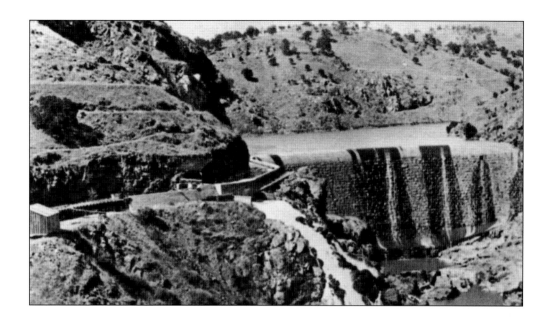

The La Grange Dam project was large, and both the Turlock and Modesto Irrigation Districts would benefit from the captured irrigation water. Workers constructed two canals off of the dam—one on the northern bank and one on the southern bank. The northern canal flows into Modesto Lake, where it is stored for use in the Modesto Irrigation District. Modesto Lake sends water to Waterford, Modesto, Empire, Riverbank, and Salida. The southern canal flows to Dawson Lake, then Floto Lake, and, finally, Turlock Lake. Turlock Lake provides water for areas including Hickman, Hughson, Ceres, Denair, Keyes, Turlock, Delhi, and even as far south as Hilmar. The above image shows the northern canal, and the below image shows the southern canal. (Above, courtesy of the La Grange Museum; below, courtesy of the McHenry Museum.)

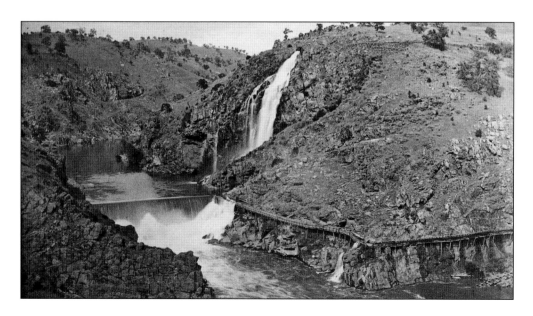

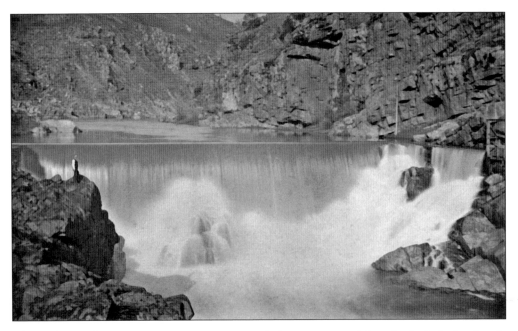

The La Grange Dam was seen as important not only for water control, but also for its hydroelectric capabilities. The La Grange powerhouse, constructed in 1924, produces four megawatts of electricity. The powerhouse is supplied with water from the flow of the southern canal. Today, the La Grange Dam is controversial because it limits the migration of the chinook salmon. It has also been recorded that as early as 1904, a powerhouse was built on the Tuolumne River to provide electricity the city of Tuolumne. (Above, courtesy of the McHenry Museum; below, courtesy of Carlo M. De Ferrari Archives.)

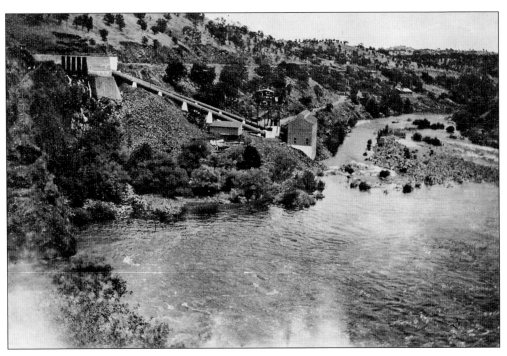

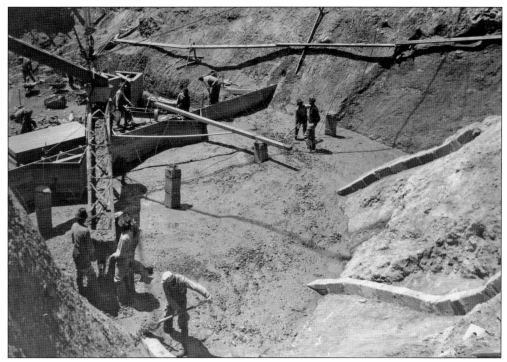

The Don Pedro Dam construction site began receiving materials and machinery in 1921. The building of the dam was difficult due to the remoteness of the location. The project required the construction of a railroad because of all the concrete needed—nearly 300,000 cubic yards of concrete were used to build the 1,000-foot-wide, 284-foot-high dam. In the c. 1922 image above, the dam is in its second half of construction. The dam's dedication took place on June 25, 1923, and welcomed over 2,000 visitors, including Michael M. O'Shaughnessy, head of the upstream Hetch Hetchy project. (Both, courtesy of the McHenry Museum.)

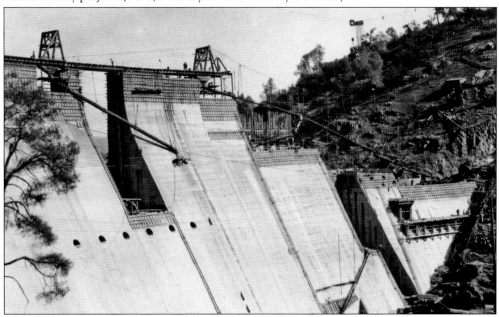

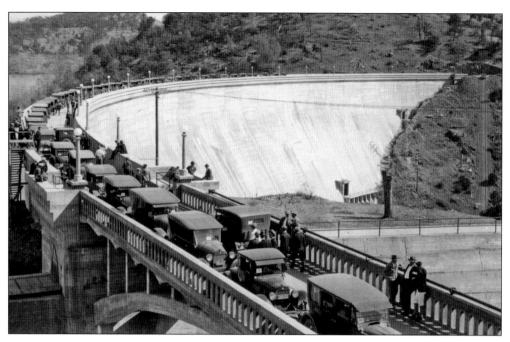

The Don Pedro Dam, a truly amazing sight in its early days, is now located at the bottom of Lake Don Pedro. The powerhouse built along with the dam was important in expanding the Turlock and Modesto Irrigation Districts. The two organizations proved to be great suppliers of electricity to the people in their respective districts. In 1925, there were around 4,000 electricity customers; by 1980, there were over 40,000 electric meters in the Turlock Irrigation District. Historian Alan M. Paterson, author of *Land, Water and Power: A History of the Turlock Irrigation District, 1887–1987*, says, "with Don Pedro, the era of pioneer irrigation was over and a time of electrical pioneering was at hand." (Both, courtesy of the McHenry Museum.)

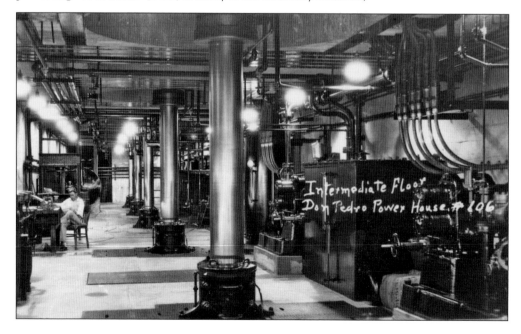

The first major structures the Turlock Irrigation District built after the dams involved wooden flumes used to transport water. This flume, pictured around 1902, brought water 23 miles from the La Grange Reservoir in the foothills. The water would arrive at the main lateral systems of canals in the Turlock region and was then diverted to farms to irrigate crops. (Courtesy of CSU Stanislaus Special Collections.)

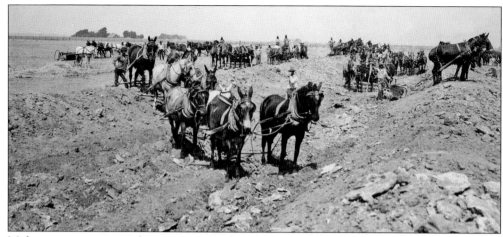

Mule teams were not only necessary for the wheat industry but also for the development of irrigation. The Fresno scraper, an improvement on older scrapers, replaced wooden components with steel ones. The above image shows mules pulling Fresno scrapers around the Turlock area. Canals needed to be cleaned out during the dry seasons; at first, they were cleaned using the same process with which they were built. That was hard work, so engineers started lining the canals with concrete. Below, a machine is preparing a canal for concrete. (Both, courtesy of the McHenry Museum.)

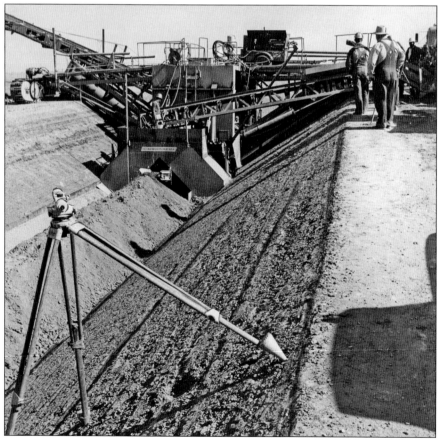

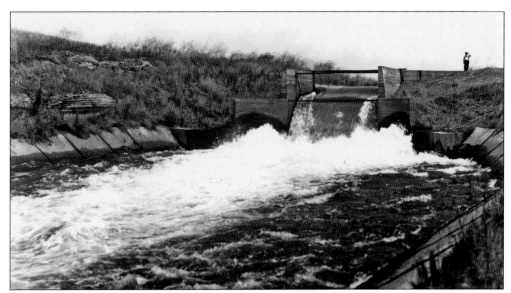

Canals have played an enormous role in the growth of Stanislaus County. They carry water from Turlock Lake and Modesto Lake to acreage used for farming and residential purposes. Stanislaus County has over 500 miles of canals under the care of the Turlock and Modesto Irrigation Districts. Canals have changed throughout the centuries—they have gone from dirt to concrete and even underground (through piping). The image above is an example of a typical paved canal that can be seen around the county. Below is an aerial view of a major canal in Stanislaus County. (Both, courtesy of the McHenry Museum.)

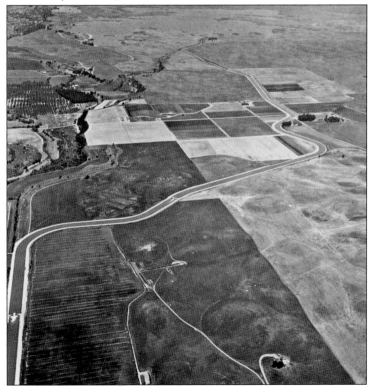

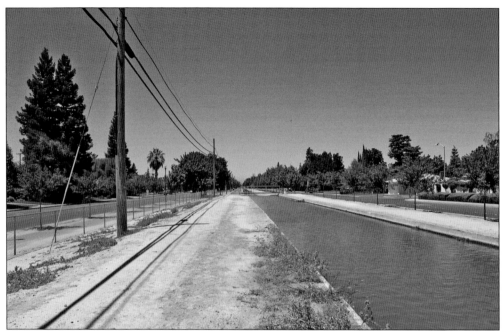

Canals are not only in the suburbs; some still run through towns and cities around Stanislaus County. The above image shows a canal running through an urban setting. Below is an example of a canal flowing through the middle of a city. Canals built in the last half of the 19th century are also used to generate electricity. The Turlock and Modesto Irrigation Districts have constructed what they call "miniature power plants" in strategic locations on canals. They do not produce the same amount of power that the La Grange and New Don Pedro powerhouses create, but they take advantage of the stored energy the water gives off as it lowers in elevation. As the towns developed, the canals had to be altered to the changing landscape. (Above, courtesy of the authors; below, courtesy of the McHenry Museum.)

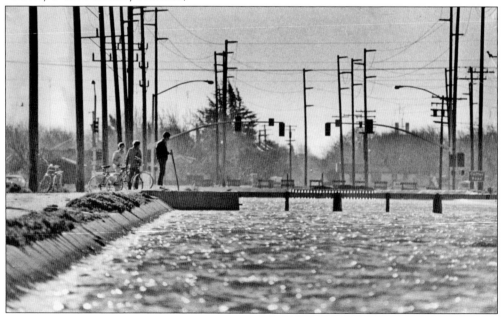

A majority of the water used for irrigation comes from reservoirs filled with snowpack melt. Many small farms along the river's edge use pumps to move water from the river to their fields. Before reservoirs, many farmers constructed irrigation ponds along the river to store water during the summer months. The river pump (right) and irrigation pond (below) in these images can be found in Ceres at the River Bluff Regional Park. (Both, courtesy of the authors.)

The population of the Central Valley has grown over the last century and shows no signs of slowing. Water wells were historically used in this area because the water table was high enough for a family to dig their own well with only a few shovels. At one point, the water table was less than 10 feet below the surface in Turlock. For the last 100 years, well water has been used to irrigate farms and provide tap water to residential areas. In some areas in Ceres, the water table is over 100 feet down and requires drilling machinery to access it. This image shows a well used in the city of Ceres to keep up with residential demand. (Courtesy of the authors.)

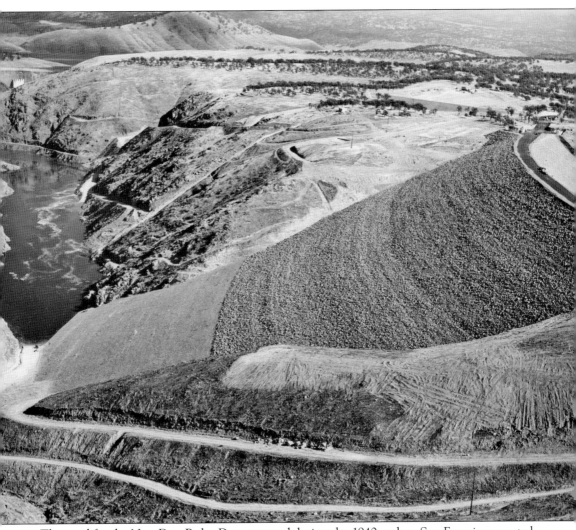

The need for the New Don Pedro Dam emerged during the 1940s, when San Francisco wanted greater water rights from the Tuolumne River. The Turlock and Modesto Irrigation Districts were both against it and used the Racker Act of 1913 to support their defense. TID's chief engineer, Roy V. Meikle, had an idea in 1943 that San Francisco could use Cherry Creek as a reservoir, and in return, the city would have to help monetarily with the creation of the New Don Pedro Dam. This New Don Pedro Dam would be owned by both TID and MID, but San Francisco could use some of the water if it needed to. The old Don Pedro Dam is visible in the upper left corner of this photograph, which was taken before the New Don Pedro Lake section was filled. (Courtesy of CSU Stanislaus Special Collections.)

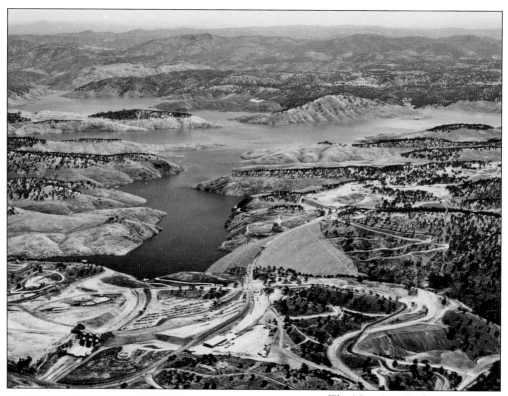

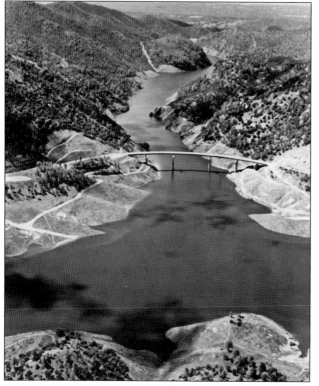

The New Don Pedro Dam is one of the biggest dams in the world. It is an earth-and-rock-fill structure that is a half-mile thick at its base and is 580 feet tall. In the above image, the New Don Pedro Dam's concrete spillways are visible at lower left. These spillways were constructed in case the reservoir becomes filled with too much water. In 1997, the spillways were opened because of heavy rain, fast snowmelts, and warm wind. The 1973 image at left shows the Jacksonville Bridge crossing over the east side of New Don Pedro Dam. (Both, courtesy of CSU Stanislaus Special Collections.)

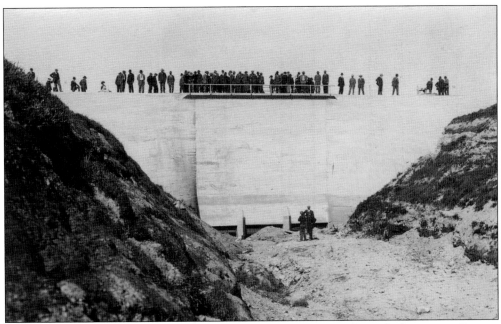

Turlock needed to contain more water from the Tuolumne River, so the Turlock Irrigation District decided to set aside a 50,000-acre-foot reservoir for its irrigation needs. It was first known as the Davis Reservoir and is now known as Turlock Lake. The outlet gate shown in the above image was created to fill the reservoir with snowmelt, seasonal rains, and diversions from the Tuolumne River. In 1914, the same year the above picture was taken, there was a defect near the outlet gate that let close to 48,000 acre-feet of water out into the canal systems. The Modesto Reservoir, the entrance to which is seen below, was completed in 1911 and stores close to 28,000 acre-feet of water. (Above, courtesy of CSU Stanislaus Collection; below, courtesy of the authors.)

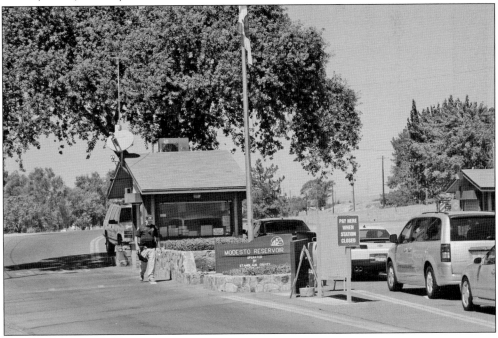

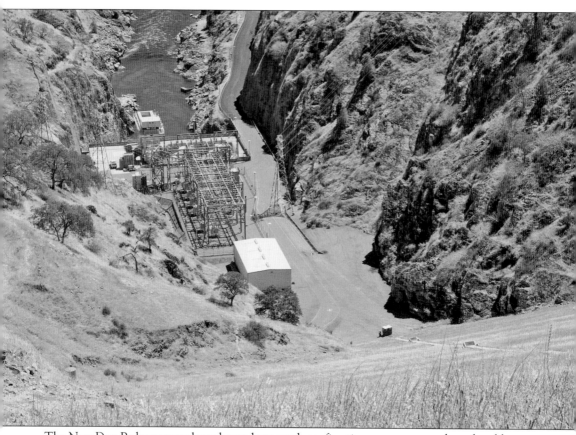

The New Don Pedro power plant shown here produces five times more power than the old power plant. The need for more water was an important factor for the creation of the New Don Pedro Dam—but not the only one. Electricity was also in high demand. In the 1950s, the Turlock Irrigation District was buying electricity from Hetch Hetchy and the Pacific Gas and Electric Company to fulfill the city's needs; the construction of the dam gave the city extra power. This image of the front side of the New Don Pedro Dam is the reflection of 110 years of irrigation that now gives water to 150,000 acres for agriculture and electricity to 150,000 clients in the heart of California. (Courtesy of the authors.)

Four

AGRICULTURE ALONG THE RIVER

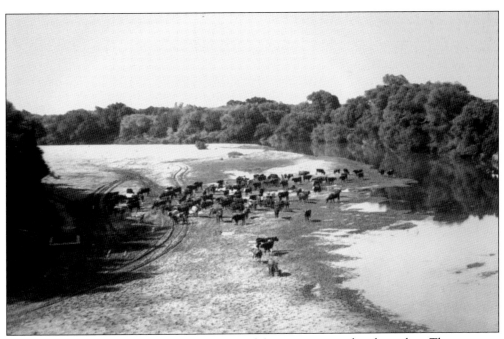

The Tuolumne River was a source of life for California natives and early settlers. The river was able to sustain large herds of cattle in the early frontier days. As shown here, cattle ranchers were able to support their cattle due to the abundance of drinkable water. The cattle-ranching business was a local source of wealth prior to the development of the wheat industry. (Courtesy of the McHenry Museum.)

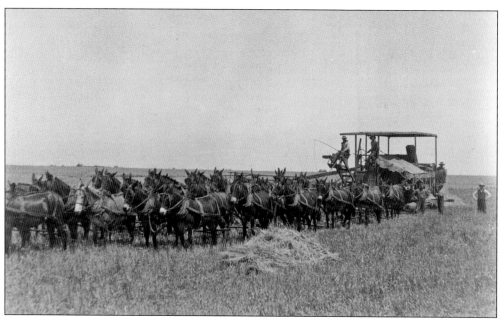

Wheat became the leading crop used in the valley, followed by barley and corn. There were grapevines and some fruit trees being grown in the area, but not at the levels of grains. The amount of water needed for fruit trees was far greater than that needed for wheat. This image shows how much extensive labor was needed in addition to the use of mules to attain an end product. Successful wheat farming brought agriculturalists from all over the world to Stanislaus County. (Courtesy of CSU Stanislaus Special Collections.)

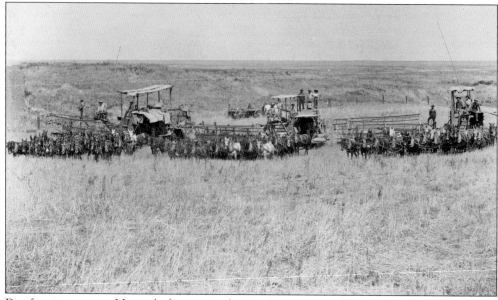

Dry farming was used by early farmers in the Stanislaus region. Crops were planted along the Tuolumne River, and farmers depended on rainfall for their crops to thrive. Stanislaus County had a serious drought in the 1870s that compelled farmers to search for a dependable source of water. They recognized early that the mass production of wheat was not going to be reliable in a region where rain was unpredictable. (Courtesy of CSU Stanislaus Special Collections.)

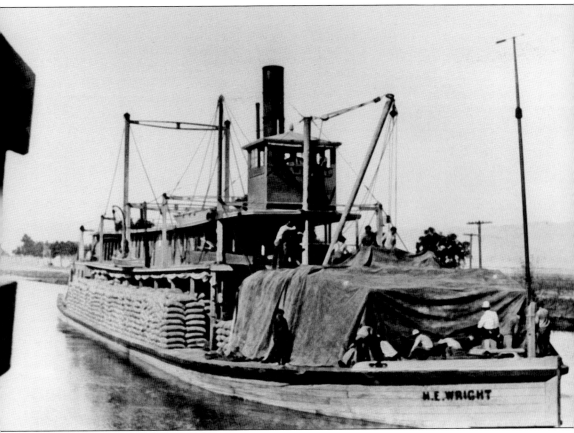

Although the railroads have played an important role in California's history, the extensive river system was the first "freeway" in California. Wheat was grown in Stanislaus County and shipped all over the state. A steamboat pulled a barge loaded with grain or crops from small towns along the river system. Grain was worthless as a commodity unless it had a market, and the river allowed that market to exist. Steamboats shipped goods from Empire to Stockton until 1917. (Courtesy of the McHenry Museum.)

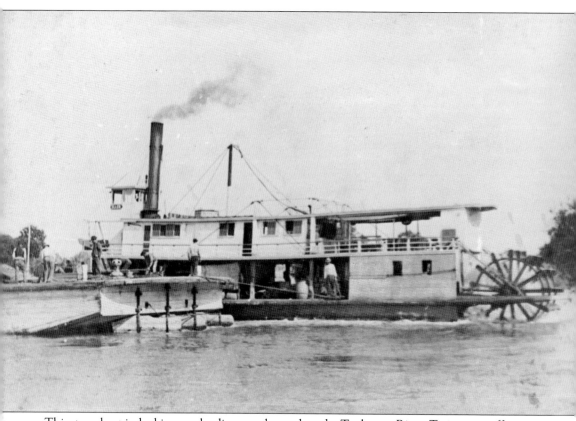

This steamboat is docking at a loading port located on the Tuolumne River. Trains were effective, but steamboats remained the cheapest form of transportation. Steamboats stopped circulating on the Tuolumne River in the early 20th century, mainly because of changes in the water flow and silt buildup along the riverbed. (Courtesy of the McHenry Museum.)

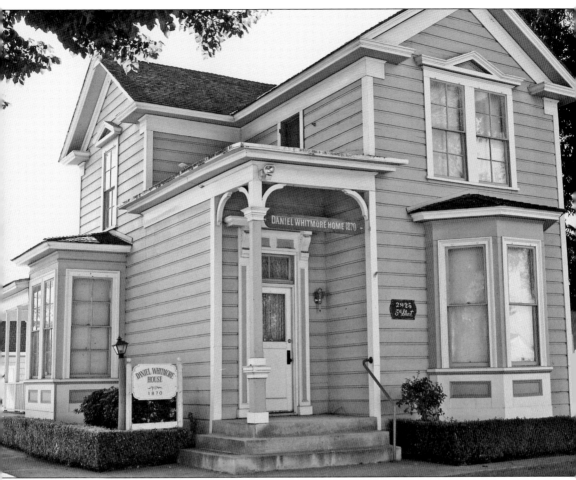

The wealth that emerged as a result of early agriculture was concentrated among certain families. One of the most important examples was the Whitmore family in Ceres. Daniel Whitmore moved to California from New England in 1854. He purchased 9,000 acres in Stanislaus County by the end of the 1860s. His land was well known along the Tuolumne River as a top producer of wheat. Ranch houses were constructed to act as headquarters for large wheat estates throughout Stanislaus County. Whitmore and selected families controlled a majority of the arable land until irrigation was developed in the region. (Courtesy of Alexander Trujillo.)

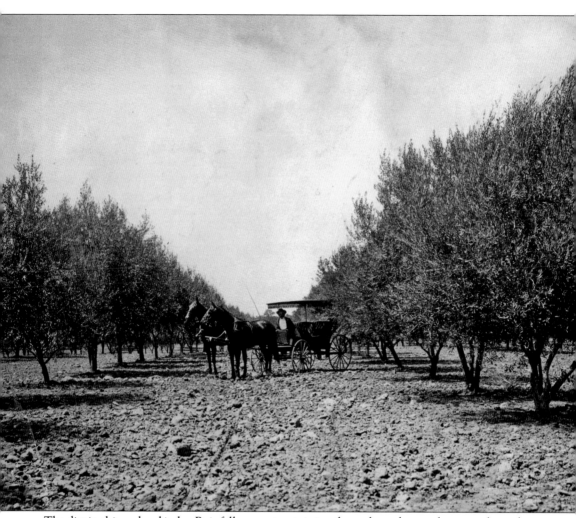

The dirt in this orchard is dry. Rainfall was not sustaining these almond trees; they were dependent on the Tuolumne River. Almond orchards have now become abundant in Stanislaus County. California is now the top exporter of almonds in the United States. The unidentified man, who may be the owner, is posing in his horse-drawn buggy. (Courtesy of the McHenry Museum.)

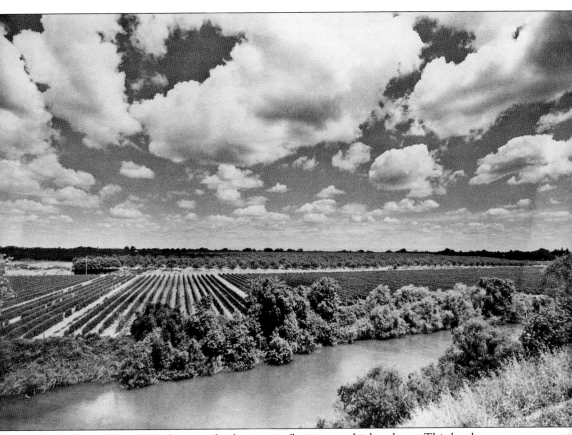

In this beautiful c. 1960 photograph, the river is flowing at a high volume. This has been a rare sight over the last 30 years because of the control of water. The New Don Pedro Dam was the final measure in taming the wild Tuolumne River. (Courtesy of the McHenry Museum.)

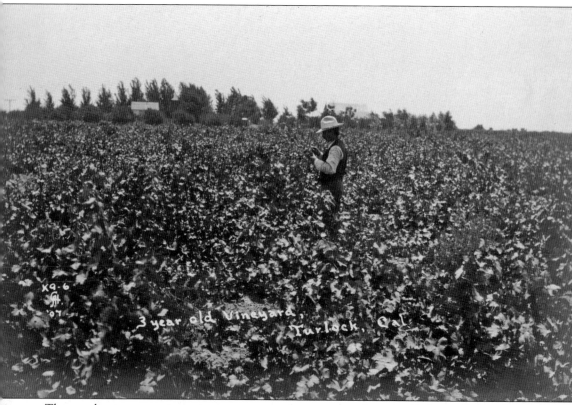

The canal system gave rise to many new towns that were not along the Tuolumne River. Turlock is miles away from the river, but it was able to gain access to the water through the development of irrigation. This image shows an unidentified man inspecting grapes produced in his three-year-old vineyard. Stanislaus County is known for its agriculture, but it is hardly recognized for its diversity. Today, California produces more wine than any other state—around 300 million gallons per year. (Courtesy of CSU Stanislaus Special Collections.)

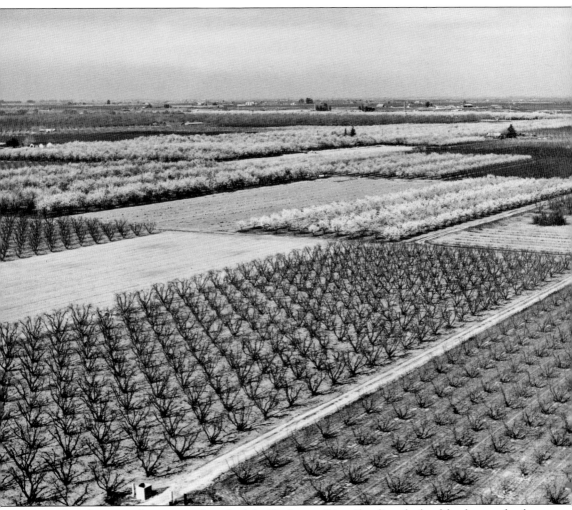

Stanislaus County is fortunate to have had the Tuolumne River flooding the land for thousands of years. This flooding allowed farmers in the valley to grow more crops in all areas of the watershed, because the soil is rich in plant-growing material such as sand, loam, and clay. This 1971 aerial view offers a great view of the almond orchards and shows how organization of agriculture has become farming practice across the county. (Courtesy of CSU Stanislaus Special Collections.)

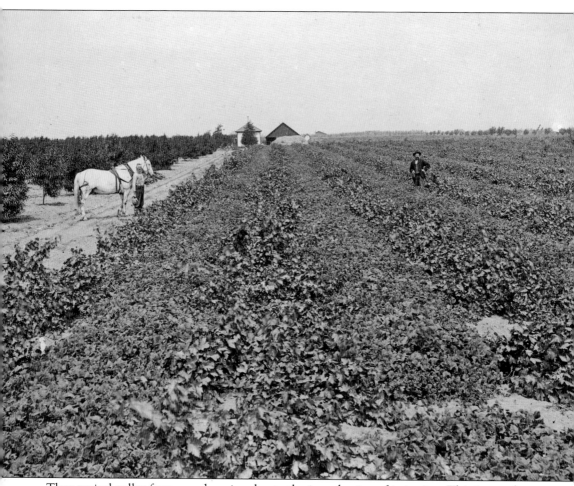

They typical valley farm was changing due to the introduction of irrigation. This image shows one of the first peach orchards planted near Turlock. An abundance of water and rich soil came together and developed the perfect medium for agriculture. The vast amount of agricultural land gave the valley life, and this image shows a background full of crops—a scene that was typical in the area. Wheat farming slowly disappeared as irrigation began to allow farmers more freedom of choice about which plants they could grow. (Courtesy of CSU Stanislaus Special Collections.)

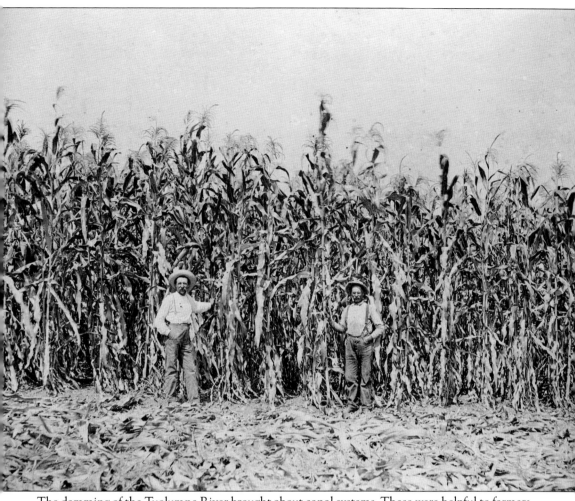

The damming of the Tuolumne River brought about canal systems. These were helpful to farmers who could now use the water in conjunction with the abundant rich soil of the valley. The amount of acres devoted to raising cattle was greatly reduced for the benefit of crops. This image, with corn growing twice the height of the men, offers evidence of the magnificence the river brought to the economy of the valley. (Courtesy of CSU Stanislaus Special Collections.)

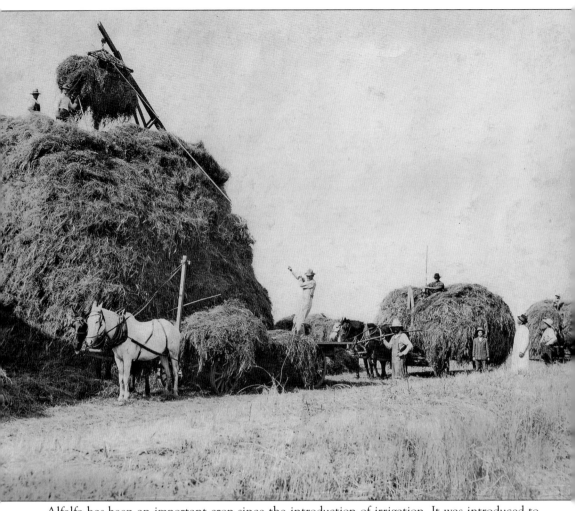

Alfalfa has been an important crop since the introduction of irrigation. It was introduced to California in the 1850s and was known as "Chilean clover." This crop has been important in the Turlock Irrigation District. In 1904, ninety-eight percent of irrigated acres held alfalfa, which is used as a forage replacement and supplement to feed livestock. This allowed for further development of the dairy industry, especially in the Turlock area. (Courtesy of the Waterford Museum.)

The walnut industry has the second-greatest amount of acres harvested and capital earned in Stanislaus County. It is second only to almonds. The Walnut Growers Association was established in 1912 and is now known as Diamond Foods. The largest portion of irrigated acres dedicated to walnut orchards are in Hughson, Ceres, Turlock, Salida, and Denair. (Courtesy of the authors.)

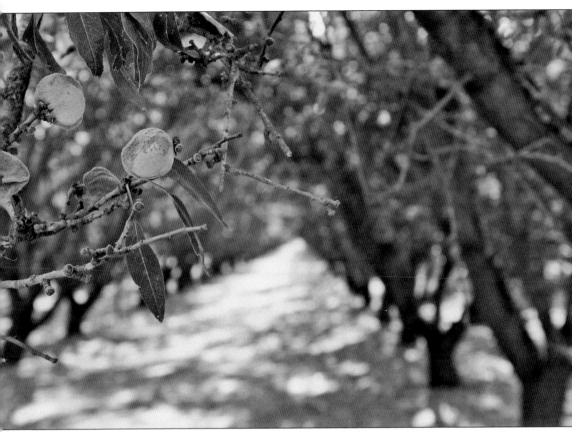

The almond industry is the greatest-producing agricultural commodity in Stanislaus County. The first almond trees grown in California were planted during the mission period (from 1769 to 1833). During the 1920s, almonds were established as a profitable crop in Stanislaus County. Due to overproduction and decrease in market value in the 1950s, peaches began to replace almond orchards. In the 1980s, the almond industry reclaimed its spot as the top-producing crop. Today, if one were to take a drive through Stanislaus County, it would not be a surprise to see almond orchards throughout the countryside. Over 15 percent of land in Stanislaus County is dedicated to growing almonds. (Courtesy of Alexander Trujillo.)

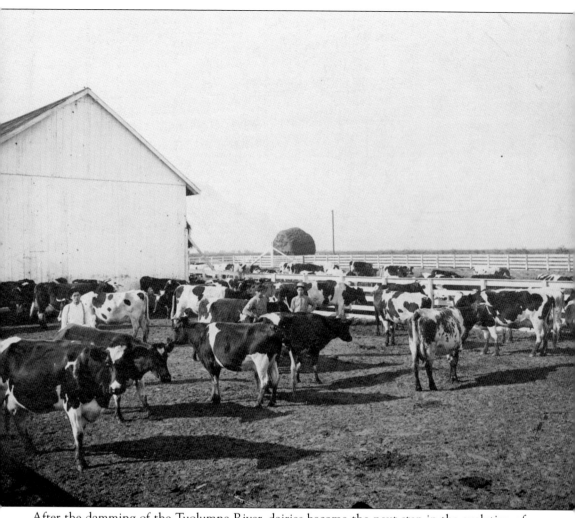

After the damming of the Tuolumne River, dairies became the next step in the evolution of the cattle industry in Stanislaus County. The old pastures became land used for planting feed, grains, melons, vines, fruits, and nuts. This livestock industry is still a heavy player, since cattle feed staples—like corn and alfalfa—are still heavily produced in the county. The production of feed allows concentration of dairies and permits higher yields. (Courtesy of CSU Stanislaus Special Collections.)

The growth of livestock industries is a result of water control. Previously, cattle had to be moved from pasture to pasture during the summer. This required large tracts of land, small herd sizes, and property along the river. With irrigation, dairy producers were able to raise large numbers of livestock with smaller plots of land and fewer employees. As irrigation forced the replacement of native grasses, it also permitted introduced species to be grown throughout the valley; this allowed for higher-nutrient feed to be grown in cattle pastures. (Courtesy of the authors.)

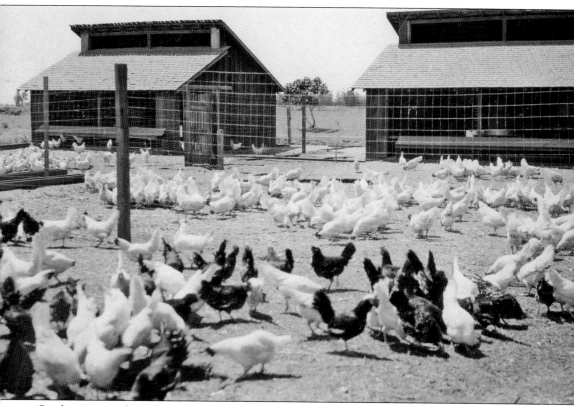

Cattle were not the only animal that created businesses in Stanislaus County, as chicken farms also arose. This c. 1925 image shows an early poultry business set up for large-scale egg production. Foster Farms, one of the leading poultry businesses in the county today, was created in 1939 on an 80-acre farm near Modesto. Many country residents also kept (and still keep) chickens, on a small scale, for personal consumption. (Courtesy of CSU Stanislaus Special Collections.)

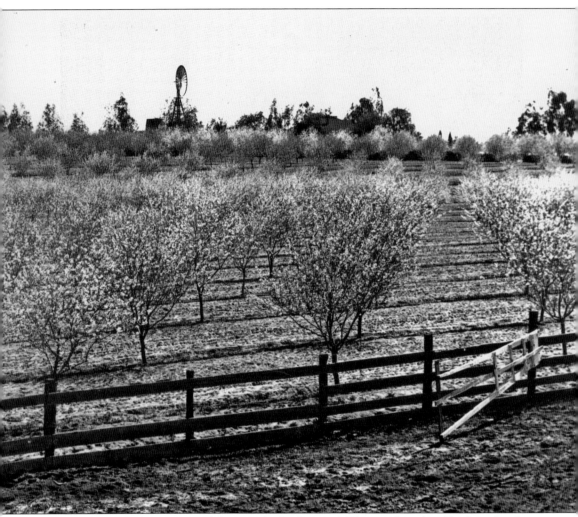

This photograph shows a typical farm in the background. The peach orchard looks to be about 15 years old. The orchard was watered by flood irrigation from nearby canals, but the house used a windmill to pull up water from the water table. Flood irrigation supplied the area with more water than was natural, so the water table rose more and more each year. This scene was typical throughout the eastern part of the old Whitmore Estate in Ceres. (Courtesy of the McHenry Museum.)

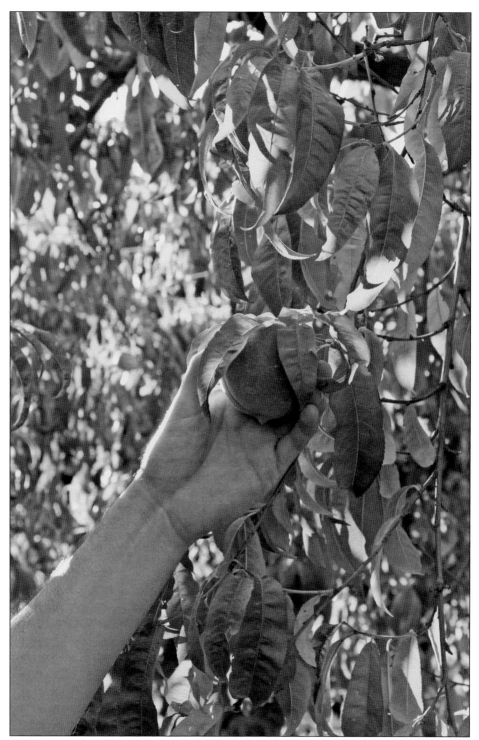

Farmers in Stanislaus County have made few changes to their harvesting methods over the last 100 years. Peaches are still picked by hand and sorted in the field before they are loaded into wooden or plastic crates. (Courtesy of Alexander Trujillo.)

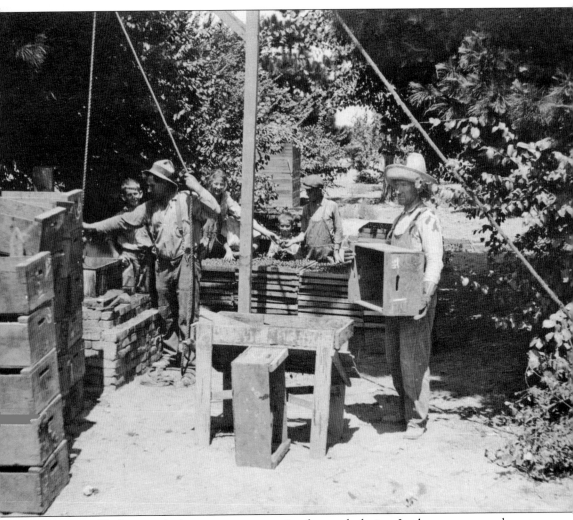

This c. 1935 photograph shows a group preparing for peach-drying. In the process, peaches are dipped into a boiling ascorbic acid mixture that helps to preserve the color of the fruit, then put into wooden frames with wire screens and laid out in the sun to dry. (Courtesy of CSU Stanislaus Special Collections.)

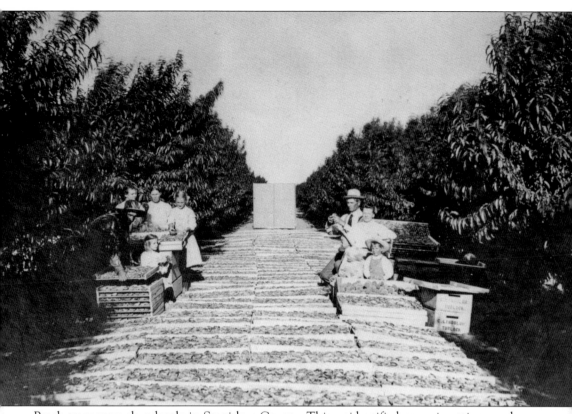

Peach trees grew abundantly in Stanislaus County. This unidentified group is setting peaches out to dry. Producers did not commonly use refrigeration for exports, so drying the fruit was not only the most efficient way to preserve harvests, it was necessary to make sure fruit was kept from spoiling during transport. The Dried Fruit Association of California formed in 1908. (Courtesy of CSU Stanislaus Special Collections.)

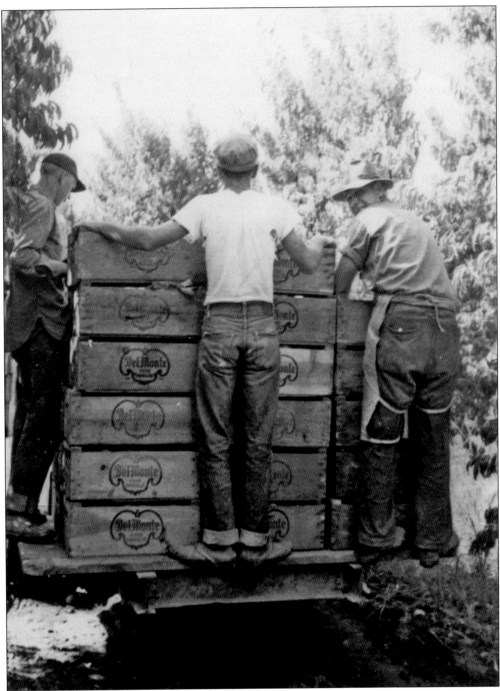

As early as the 1880s, distribution companies began selling crops from small farms across California. In this image, the boxes of harvested peaches are marked with the Del Monte label. Del Monte started over 100 years ago in San Francisco and remains one of the largest agribusiness corporations in North America. The company sells close to $4 billion of product each year. In Stanislaus County, Del Monte employs thousands during the harvesting months. (Courtesy of the Hughson Museum.)

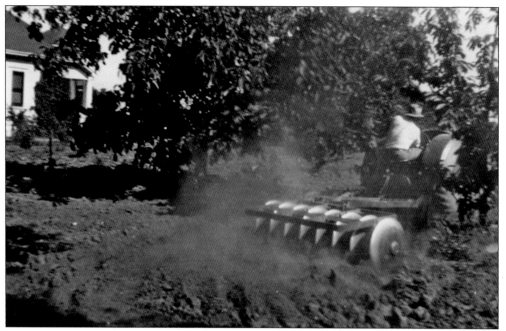

In the dusty scene above, a man is pulling a disc in his walnut orchard. Along with the introduction of irrigation, there were many technological advances in the 20th century. Farmers no longer needed large labor groups to pull weeds and prepare the soil for irrigation. Although technology helped farmers, the Tuolumne River was and is still essential for providing life in the fields. The below image shows a man plowing a field in preparation for next year's planting. (Both, courtesy of the McHenry Museum.)

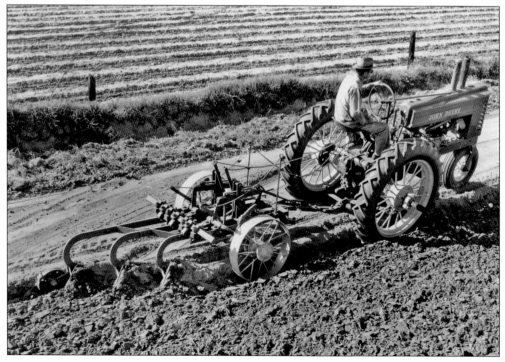

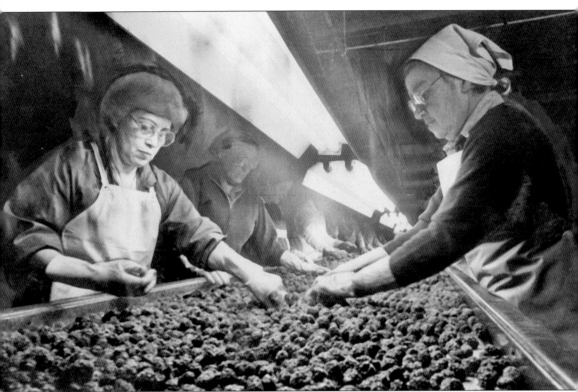

The labor involved with producing crops did not end in the field. Preliminary sorting of fruit takes place in the fields, but because of greater quality control in the agricultural industry, it additionally occurs in factory-like settings. This 1984 photograph is important for recognizing the role of women in the agricultural workplace. The growth of agriculture in the area has created jobs throughout Stanislaus County, especially in food-processing factories. (Courtesy of the McHenry Museum.)

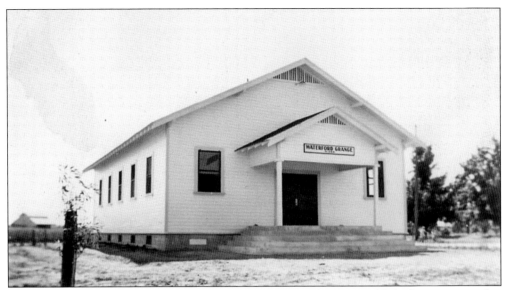

During the early development of agricultural communities, farmers established co-ops to market produce. Prior to the co-ops, many towns had Granges. The Waterford Grange (above) was at its busiest during the 1930s. The organization sent representatives to Sacramento to lobby for an expansion of agricultural marketing in Stanislaus County. The below image shows an award given to the Waterford Grange in 1961 for its community service. Granges served as meeting places for area farmers and provided a space for the sharing of ideas. (Both, courtesy of the Waterford Museum.)

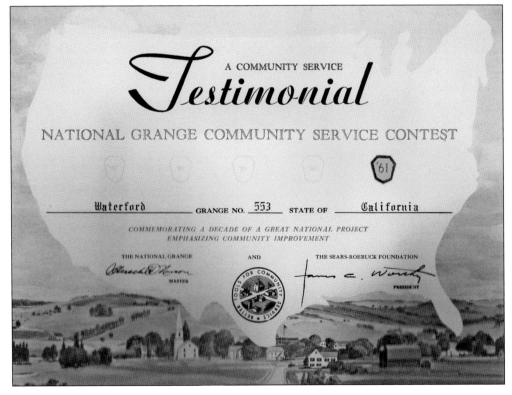

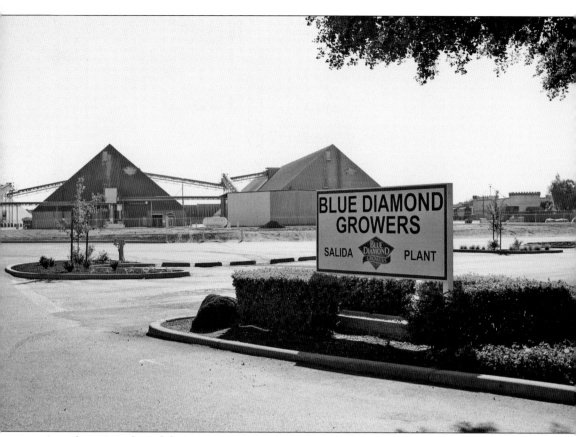

As early as 1910, almonds became a growing industry in California. Blue Diamond Growers (initially called California Almond Growers Exchange) started as a cooperative of 230 almond-growers. Over 80 percent of the world's supply of almonds is produced in California because of the organization and marketing provided by Blue Diamond Growers. Stanislaus County has been recognized over the years as a major producer for this cooperative. (Courtesy of Alexander Trujillo.)

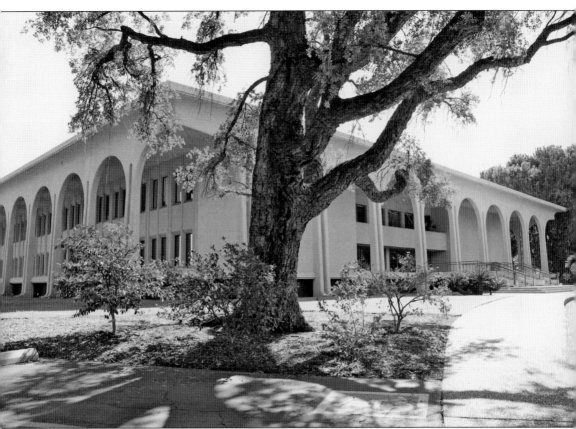

California is known around the world for its wines. Wine manufacturing was introduced to California in the 1700s by Spanish missionaries. E. & J. Gallo Winery (pictured), founded in Modesto in 1933 by brothers Ernest and Julio Gallo, is one of the world's largest wine producers. The company is now the largest family-owned winery in the United States and is still headquartered in Modesto. (Courtesy of the authors.)

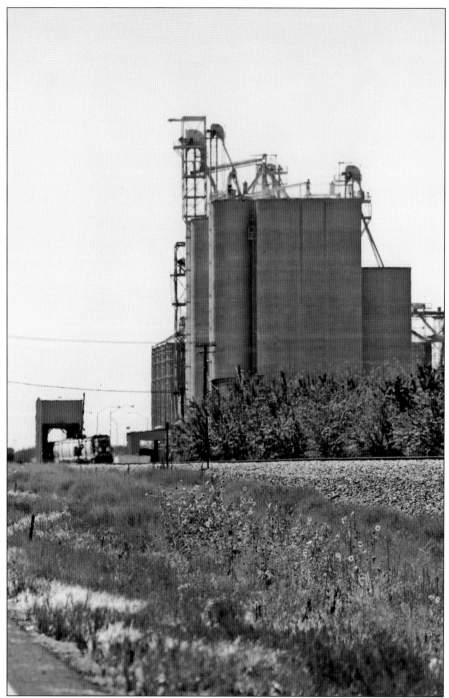

Stanislaus County, first known for its cattle and grain industries, is now recognized for its production of fruits and nuts. For the last 100 years, railroads have been essential in providing the county with reliable transportation for agricultural products. This grain mill is located along the Santa Fe Railway in Turlock. Stanislaus County farmers still raise livestock, but they are unable to grow enough necessary grain. Grain mills can be seen towering over towns and orchards all along the railroads running through the region. (Courtesy of Alexander Trujillo.)

Five

TOWN DEVELOPMENT

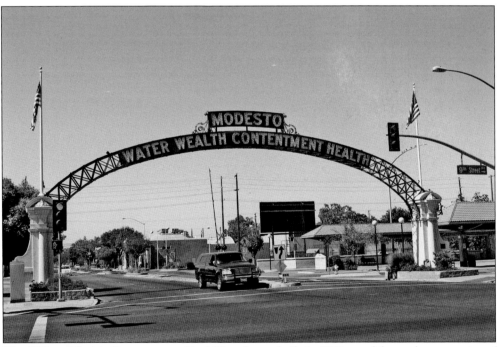

The "Water Wealth Contentment Health" arch was built in 1912 to celebrate the prosperity of the region. The arch was constructed by the Modesto Booster Club, founders of the chamber of commerce. This sign at the intersection of Ninth and I Streets still welcomes tourists to Modesto. The city has experienced the most growth in Stanislaus County, which was possible through the expansion of agriculture. Since Modesto is the county seat, the sign has become a representation of what is offered in the Central Valley. (Courtesy of Alexander Trujillo.)

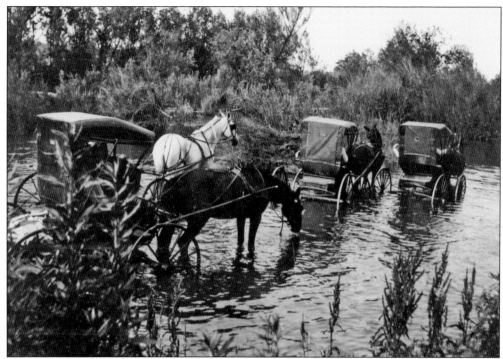

Before ferries or bridges, men and women had to find the shallowest place on the river in order to cross it. The above image shows three horse-drawn buggies crossing the Tuolumne River. This was a typical scene in the early years of settlement in Stanislaus County. The ferry system that developed in Stanislaus County was very basic: It required the strength to pull the ferry from a rope that was tied on both banks of the river. The ferry system was initiated in the late 1800s and lasted until a few bridges had been built along the Tuolumne River. The Angelo Basso ferry, seen below, was important for the development of the upper Tuolumne River. (Above, courtesy of the McHenry Museum; below, courtesy of the La Grange Museum.)

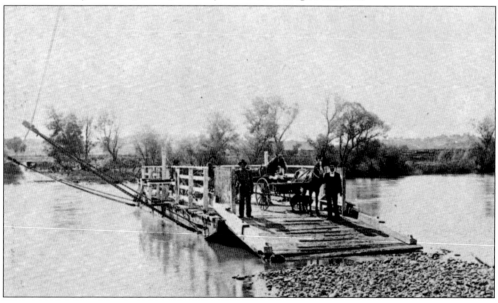

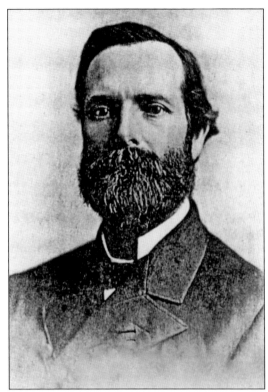

Some of the first immigrants to Stanislaus County were semi-wealthy families who purchased large tracts of land. The man at right, Hiram Hughson, is recognized as the founder of Hughson, California. Like many of the early settlers in Stanislaus County, he was a wheat farmer. His closest ranching neighbor was Daniel Whitmore from Ceres. Pictured below, Robert McHenry is known as the founder of the Modesto area because of his involvement in building community infrastructure. His mansion in Modesto is a local attraction. (Right, courtesy of the Hughson Museum; below, courtesy of the McHenry Museum.)

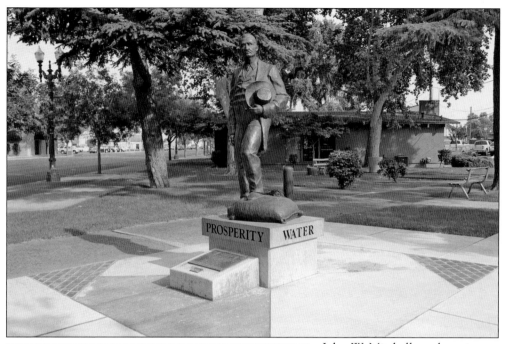

John W. Mitchell was born in Woodbury, Connecticut, in 1828. He came to San Francisco in 1851 after the Gold Rush. He saved his earnings from the gold mines and was able to buy land in Stanislaus County. At the height of his wheat empire, Mitchell owned over 100,000 acres in the county; he founded the city of Turlock in 1871. A statue erected in his honor (pictured above) can be seen on the corner of Golden State Boulevard and West Main Street in Turlock. The left image shows William W. Baker in his later years. Baker was born in Berryville, Arkansas, in 1835 and eventually made his way to California, where he purchased land along the Tuolumne River to make his wheat fortune. Known as the founder of Waterford, Baker passed away there in 1885. (Above, courtesy of the authors; left, courtesy of the Waterford Museum.)

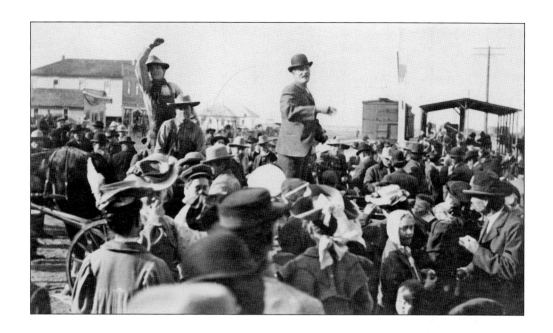

Stanislaus County became a very desirable place for families to thrive and achieve the American dream. Around the start of the 20th century, it was common to see a crowd of potential buyers around an auctioneer. Throughout the United States, newspapers and magazines would testify to the available land in California. One magazine advertisement read, "The best alfalfa and fruit growing section in the world. The district where the land owns the water." The land would become green, but not until irrigation was established years later. The men in these images are auctioning land to new arrivals. The below image was taken around 1907. (Both, courtesy of CSU Stanislaus Special Collections.)

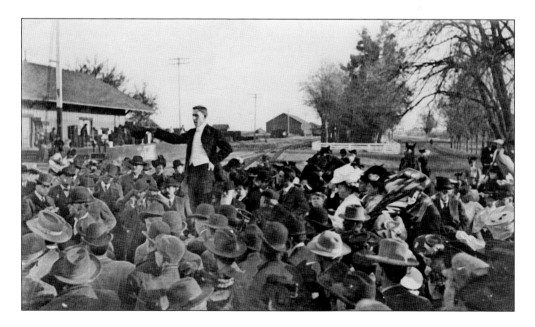

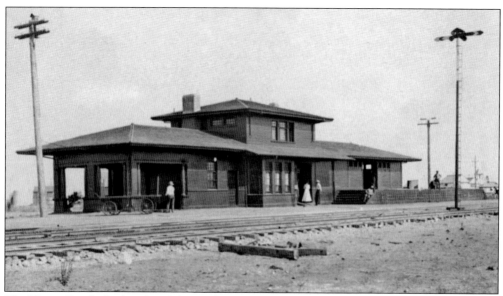

The Union Pacific Railroad and the Burlington Northern & Santa Fe Railway (BNSF) are the two current railways that operate in the Central Valley of California. The two railroads began operating in the 19th century and were essential in moving agricultural products. They effectively replaced the ferry-and-barge system in the first half of the 20th century. The above picture shows the Santa Fe Railway depot in Hughson in 1909. The towns that have grown most over the last 100 years have been those which had access to railways, such as the Modesto Train Station, seen below. The railroads were essential in moving large populations to Stanislaus County during its earliest growth period. (Above, courtesy of the Hughson Museum; below, courtesy of the McHenry Museum.)

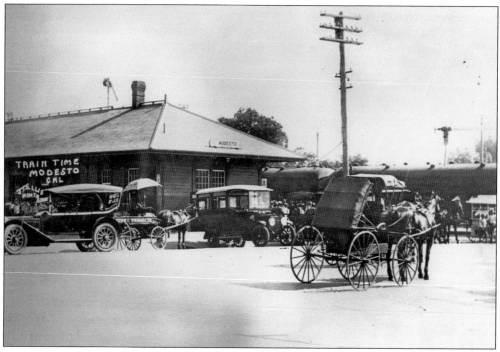

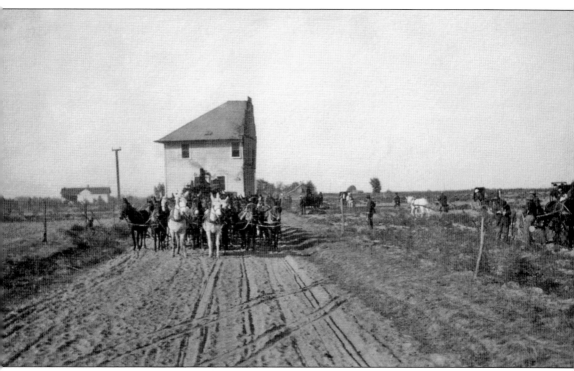

At the start of the 20th century, towns along the lower portion of the Tuolumne River were growing very quickly. Many of these towns not only received citizens from other towns but also those citizens' homes. The Hughson Hotel, originally located in Ceres, was moved to Hughson in 1907 by teams of 40 to 60 mules from the Tomlinson, Fox, and Crow ranches in the Hughson area. Many buildings were cut in half and moved to their destinations over a course of weeks. (Courtesy of the Hughson Museum.)

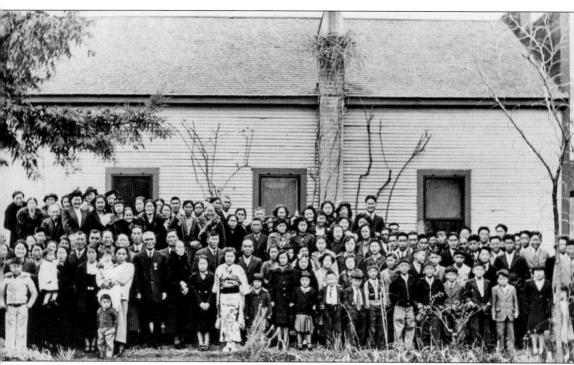

Irrigation brought many jobs that were not filled by the population in the county. This 1939 image shows a group of Japanese Americans in Turlock during a New Year's celebration. California had discriminatory laws that barred the Japanese from owning land, but they were able to lease farmland to plant cantaloupe and other crops. The Central California Cantaloupe Company, organized by Nisaburo Aibara, was located in Turlock and helped with economic and legal issues pertaining to cantaloupe farms. (Courtesy of CSU Stanislaus Special Collections.)

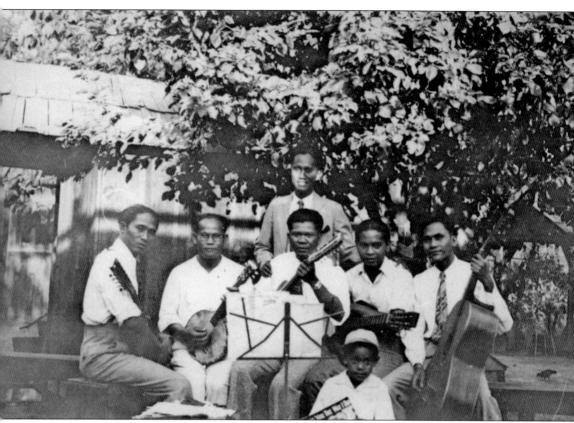

With the many farms created after irrigation, labor became a concern for farm owners. This c. 1925 image shows six unidentified Filipinos. They are contracted seasonal workers brought from the Philippines to work near Turlock. Steve Andrino, in Stanislaus County, was a labor contractor who brought most of the Filipinos to work in the fields. The laborers would generally start at the southernmost portion of Stanislaus County and move north as crops ripened. Many seasonal workers found the area to be comfortable and decided to stay and start their own farms. (Courtesy of CSU Stanislaus Special Collections.)

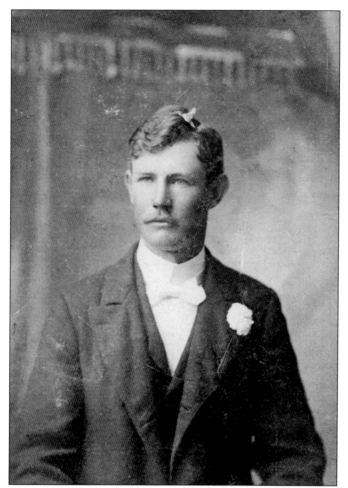

In 1903, John Beck, an English immigrant, purchased land from the Whitmore Estate on the south side of the Tuolumne River. Beck's farm, today known as Souza Farms, started at 40 acres and is still 40 acres today. The ranch was used to grow wheat, alfalfa, and peaches, and it is now used to produce almonds. The family house (pictured in the background of the image below) was built in 1908 is still standing today. (Both, courtesy of the Souza family.)

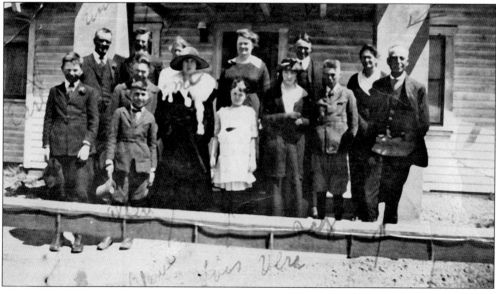

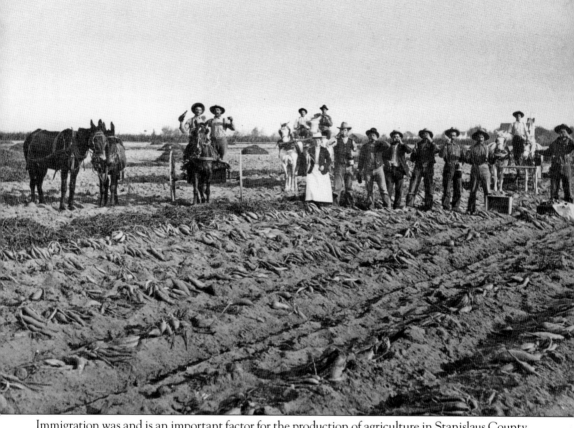

Immigration was and is an important factor for the production of agriculture in Stanislaus County. The region has an abundance of land and of water, but it still requires people to grow the staples. This photograph shows Portuguese farmers toasting their bumper crop of sweet potatoes. Sweet potatoes are still grown in the county—close to 1,500 acres of the crop are harvested each year. (Courtesy of CSU Stanislaus Special Collections.)

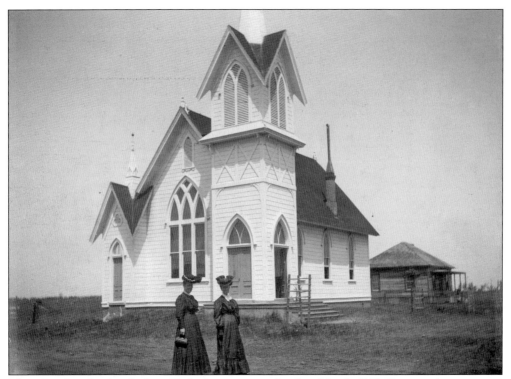

This church—the first built in Turlock—was completed in March 1889. Due to administrative issues, it only operated for three months. The building was later sold to the Brethren Church in 1902. The woman on the left is identified as Abigail Fulkerth, known as "Aunt Abby," and the woman at right is unidentified. The immigration of people from all over the United States allowed for the establishment of a great diversity of churches in Stanislaus County. At one point in time, Turlock had more churches per square mile than any other town across the United States. (Courtesy of CSU Stanislaus Special Collections.)

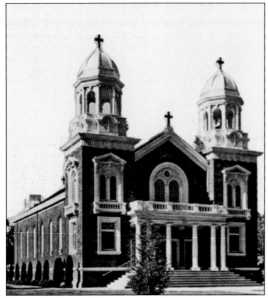

Catholicism was first introduced to California by the Spanish missionaries. The first Catholic mission in Turlock was built in 1888. Irishman James Kehoe was instrumental in gathering the Irish community around Turlock to help construct the mission. The first site, on the corner of Broadway and A Streets, was on land donated by John Mitchell. The parish moved in 1912 and rebuilt in 1972 on the corner of Lyons Avenue and Rose Street, where the Sacred Heart Catholic Church stands today. This image shows the 1912 location. (Courtesy of Sacred Heart Parish.)

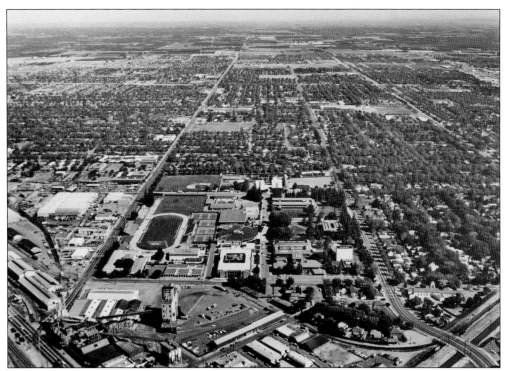

Farming was not the only industry fostered by the damming of the Tuolumne River. State-funded colleges soon followed with the creation of Modesto Junior College (MJC), which was built in 1921 and became the first junior college in California. In the 1969 image above, MJC is still in operation and charges cheaper tuition to students from around the valley. In the image below, California State University (CSU), Stanislaus was founded in 1957 and held its first classes at the Stanislaus County Fairgrounds in 1960. In 1965, CSU Stanislaus moved to its present location in the northern part of Turlock. This campus was originally built in the countryside on a former turkey farm, but is now surrounded by housing developments. (Both, courtesy of CSU Stanislaus Special Collections.)

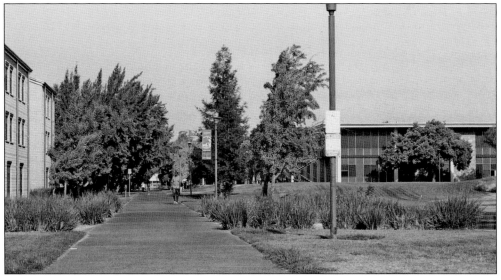

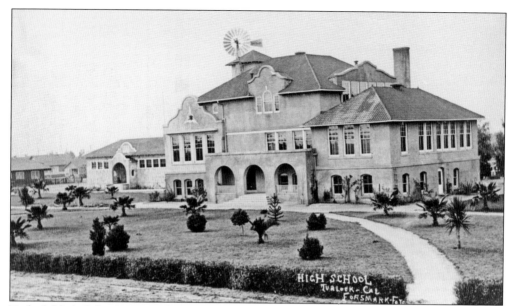

Turlock High School, pictured above, was built in 1906. It served as the main high school for six grammar school districts—Washington, Central, Mitchell, Tegner, Keyes, and Turlock. The building shown was used from 1907 to 1922. Students who wanted to continue their education past eighth grade had to travel or move. Today, 188 public schools serve nearly 104,000 students in Stanislaus County. The 1900 image below shows the East Side Grammar School on Fourteenth Street in Modesto. (Above, courtesy of CSU Stanislaus Special Collections; below, courtesy of the McHenry Museum.)

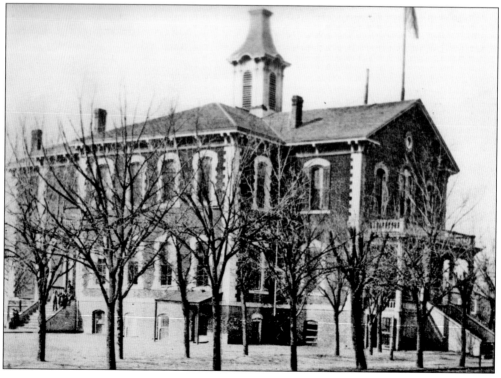

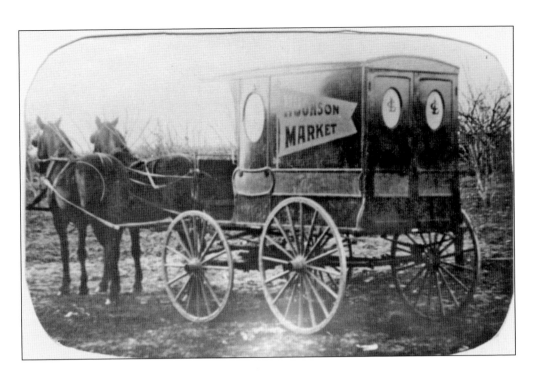

The above image shows a horse-drawn cart bearing an advertisement for the local Hughson Market. Farmers were able to harvest sufficient produce to feed local citizens, then the harvest began to explode in such abundance that farmers needed to expand their markets. The railroad became a gateway to markets all over the United States, allowing farmers to send products nationwide. Below, farmers with wagons full of watermelons wait in Hughson before unloading cargo destined for sale in distant markets. (Both, courtesy of the Hughson Museum.)

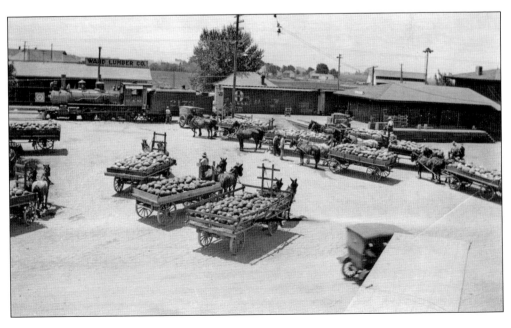

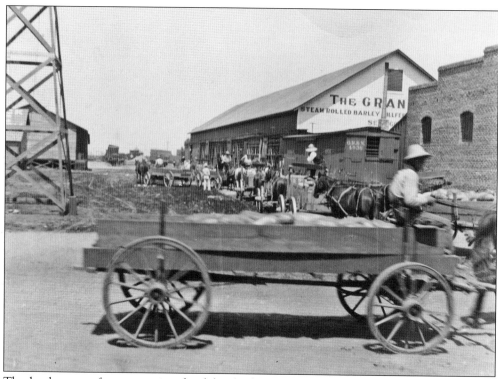

The development of a town requires the ability for the community to provide economic opportunities for its residents. Turlock was able to provide this with its vast amounts of land and water. The watermelon industry took such a great leap that customers from the east would come to Turlock to buy loads of watermelon. Farmers merely had to take their crops to the Southern Pacific train depot to sell their harvest. Grapes were another crop that local farmers would bring to the depot to sell to markets around the United States. (Both, courtesy of CSU Stanislaus Special Collections.)

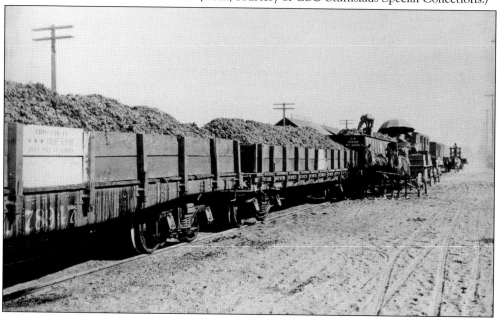

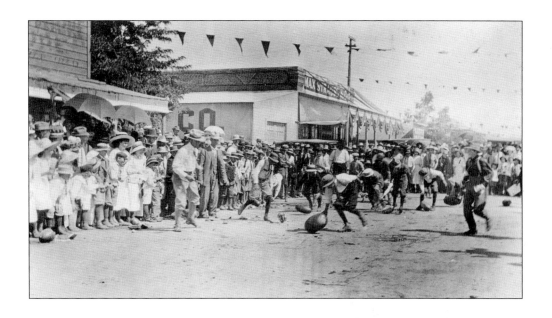

Turlock was known as the "Watermelon Capital of the World," and the townspeople celebrated what they were known for. The c. 1912 photograph above shows a group of young boys participating in a watermelon-rolling contest. Thanks to the water from the Tuolumne River, the harvest was so bountiful that people could allow a few watermelons to go to waste. The Melon Festival of Turlock had a variety of competitions, including a watermelon-eating contest. The c.1911 image below shows Jubal Hains having a go with a large slice of watermelon. Hains won first prize, which was $50. (Both, courtesy of CSU Stanislaus Special Collections.)

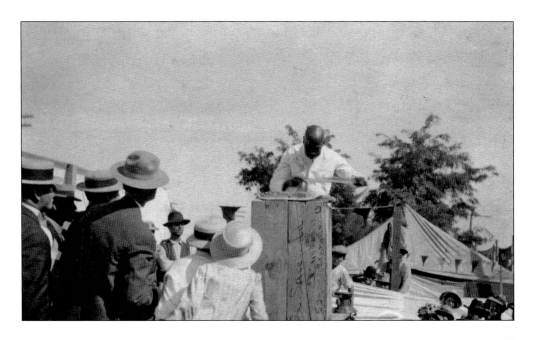

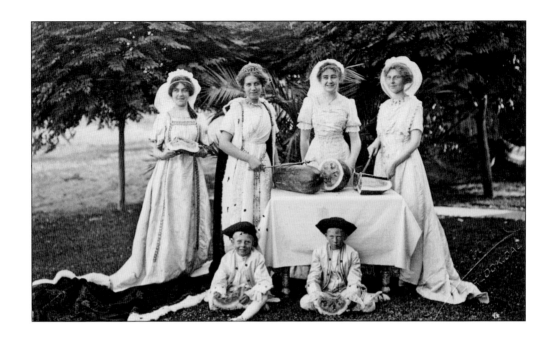

The Turlock Melon Carnival celebration was first held on August 24 and 25 in 1911. In 1934, the celebration became known as the 38th District Fair; it is now known as the Stanislaus County Fair and is held sometime in July of each year. The above image shows the first Melon Carnival Queen surrounded by her attendants. The carnival also featured a parade that included floats such as those drawn by horses in the below image. (Both, courtesy of CSU Stanislaus Special Collections.)

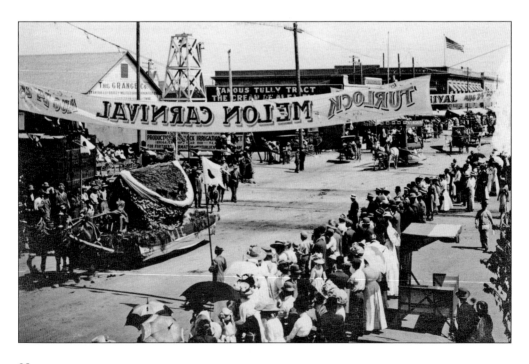

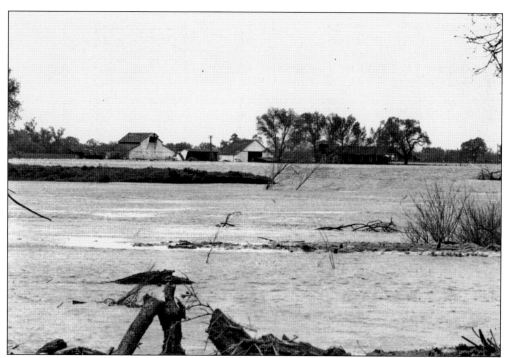

Prior to the construction of dams on the Tuolumne River, the valley received large amounts of water when the snowpack melted quickly during warmer years. Areas that now contain towns—including Hughson, Ceres, Empire, and Modesto—would become flooded in the spring. The last major flood occurred in 1997, when the New Don Pedro Dam was unable to keep the river tamed. (Both, courtesy of the McHenry Museum.)

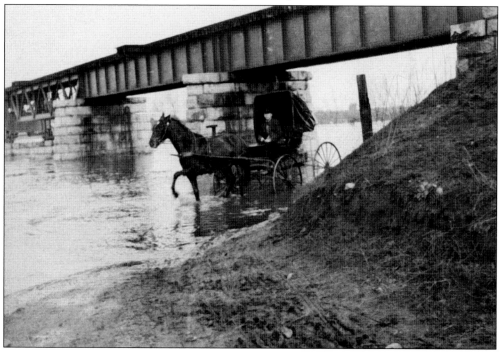

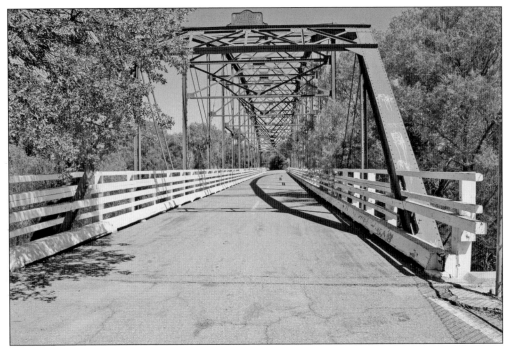

As the county began to develop land in the foothills, it became necessary to establish a safe crossing in the La Grange area. The Old Basso Bridge (above) was built in 1912 and is located below La Grange on the Tuolumne River. The bridge replaced the original Angelo Basso ferry. Today, it is no longer in use for automobiles, but it was restored in 1986–1987 as a pedestrian bridge. Car traffic to La Grange now overpasses the river on a modern concrete bridge, known as the New State Route 132 Bridge (below). (Both, courtesy of the authors.)

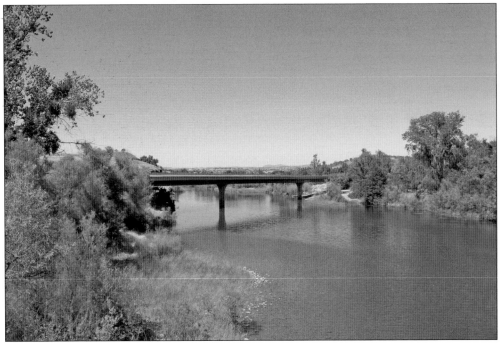

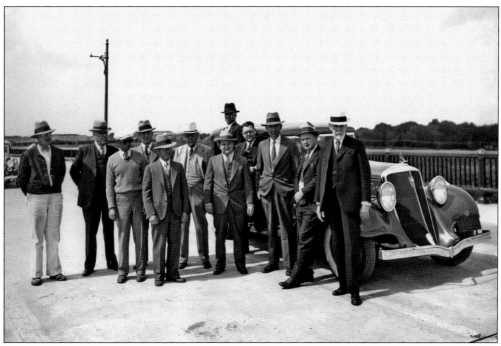

In the lower part of the Tuolumne River region, the construction of reliable bridges was important. As the railroads created boomtowns in the Stanislaus County, Modesto recognized that the city needed a bridge that would last for a century. The Seventh Street Bridge, opened in 1916, connects Modesto to the southern half of the county (near Ceres). The bridge spans over the floodplain carved out by the Tuolumne River for thousands of years. In the above image, men pose for a picture on the bridge in 1933. In the picture below, people make their way across the Seventh Street Bridge, which is sometimes called the "Lion Bridge." (Both, courtesy of the McHenry Museum.)

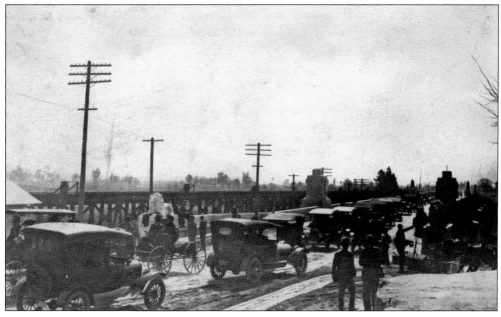

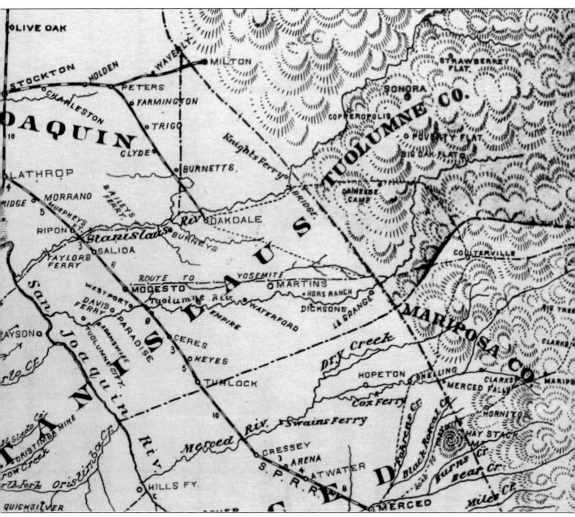

Stanislaus County's first towns—Paradise City, Adamsville, Grayson, and Tuolumne City—were established along or near the river. Most of these started as ferry towns, where people were able to cross the river. As the *Tuolumne City News* of June 18, 1868, reports: "Having a good landing on the Tuolumne River, and being situated on the edge of an ocean of grain, there can be no doubt of a heavy business being done the present season, and we are highly pleased to witness its prosperity." These towns may no longer exist, but they were important in directing Stanislaus County toward agricultural production and development. (Courtesy of the Waterford Museum.)

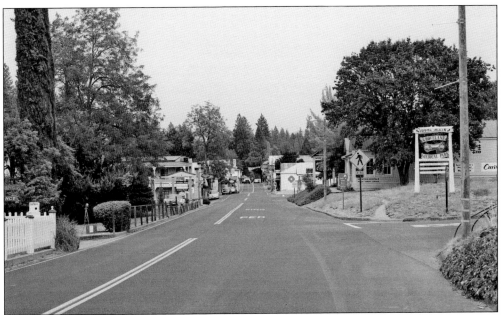

Many towns sprang up along the river east of Lake Don Pedro during the Gold Rush era. Groveland (above) originally served as a headquarters town where miners could rest and get supplies. The town faded away until the Hetch Hetchy project put it back on the map. Groveland was and still is a gateway to Yosemite National Park. The City of San Francisco constructed the town of Moccasin (below) to house workers who manage the Moccasin Powerhouse. The unincorporated town, which is still owned by the city, is not open to the public, but tours are available to anyone interested in the community. Both of these towns are located in Tuolumne County near the upper part of the Tuolumne River. (Both, courtesy of the authors.)

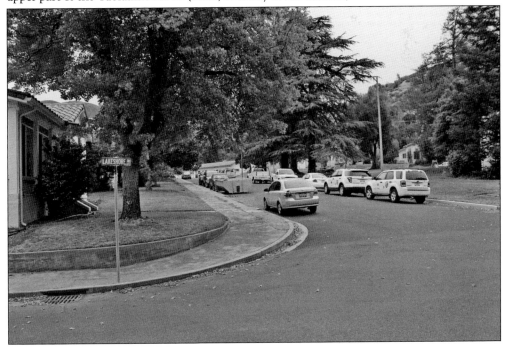

Chinese Camp (above), located on the west side of the original Lake Don Pedro, was established as a mining town. The community got its name when Chinese miners began moving into the community known as "Camp Washington." Many towns and cities had Chinese divisions, but this town was different. The Chinese, who were widely disliked by white miners, moved to this location and found a safe haven. Coulterville (below) is located east of the original Lake Don Pedro and was first inhabited by George W. Coulter in 1850. The town was used as a stopping point for those heading to the gold mines in the uppermost part of the Tuolumne River. These towns are both located in Tuolumne County. (Above, courtesy of the authors; below, courtesy of Alexander Trujillo.)

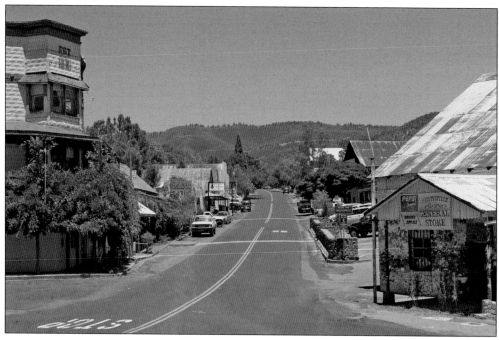

La Grange is one of the more important towns located along the upper portion of the Tuolumne River. Established as a French settlement in 1852, La Grange later became famous for its large gold dredges along the river. La Grange was a real Wild West town, complete with gunfights, mining, and saloons. It was large enough to serve as the Stanislaus County seat from 1854 to 1862, for it had a population in the thousands. Today, the town is a stopping point on the drive to Lake Don Pedro; some of the original buildings still stand on Main Street. (Above, courtesy of the authors; below, courtesy of the La Grange Museum.)

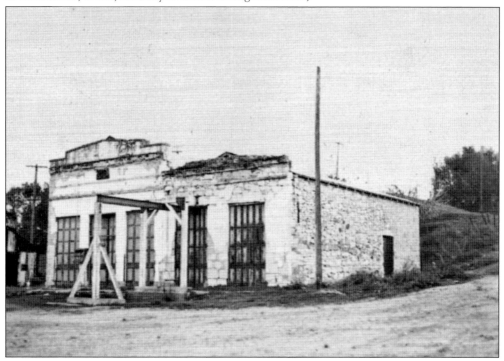

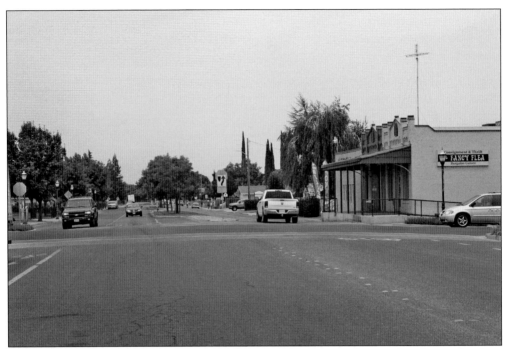

The towns of Waterford and Hickman developed across the river from each other, and a ferry bridged the river between the two settlements. Today, Waterford is growing both agriculturally and in population. As the almond industry continues to expand in California, the Waterford hills are sprouting almond orchards. Hickman, located on the southern side of the Tuolumne River, is still a community of less than 1,000 people. Hickman is known in Stanislaus County as a small and quiet community. (Both, courtesy of the authors.)

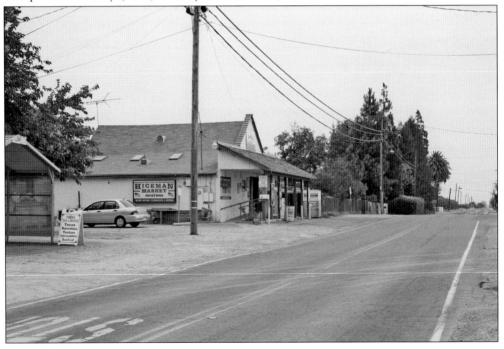

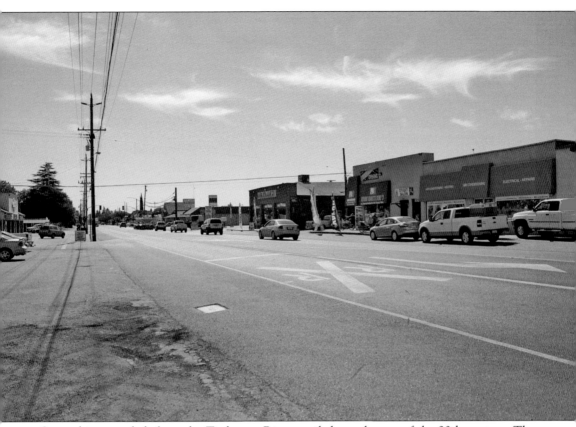

Steamships traveled along the Tuolumne River until the early part of the 20th century. The settlement of Empire was essentially established as a port for the shipment of wheat. Farmers would bring grain to barges, and steamships in Empire would pull the barges to main ports in Stockton. Today, Empire is part of the Modesto metropolitan area. (Courtesy of Alexander Trujillo.)

Ceres was developed out of Daniel Whitmore's estate south of the Modesto area. The land there, primarily used for the production of wheat, was parceled off around 1900 and was sold to many small farmers from across California. Hughson, founded in 1907 and named for prominent early landowner Hiram Hughson, is a thriving agricultural town. These towns are both best known for their production of almonds and peaches. (Above, courtesy of Alexander Trujillo; below, courtesy of the authors.)

Due to the introduction of irrigation, many agricultural towns were able to develop farther away from the river. Keyes (above), located south of Ceres, was developed out of the northern part of the Mitchell Ranch. Many in Keyes believe that the community was named after Sen. Thomas J. Keyes. Denair (below), located east of Turlock, is a small community founded in 1904 along the Santa Fe Railway tracks. The settlement was named after local landowner John Denair. (Above, courtesy of the authors; below, courtesy of Alexander Trujillo.)

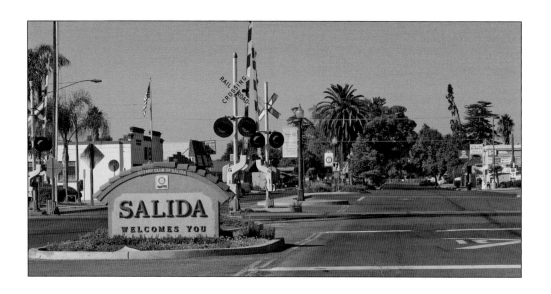

The Stanislaus River is located at the northern border of Stanislaus County. Salida (above) was founded in 1870 and is largely an almond-growing region. The city was set up in this location because of the establishment of the original Burneyville Ferry on the Stanislaus River. The city of Riverbank (below) is known for being the close neighbor of Oakdale, but it is part of the Modesto Irrigation District. Although it may be close to the Stanislaus River, it uses Tuolumne River irrigation. (Above, courtesy of Alexander Trujillo; below, courtesy of the authors.)

Hilmar (above) was founded in 1917 by northern European immigrants for the purpose of starting small farms. Delhi (right) received its first post office in 1912 and is known for its large Hispanic community. Although these towns are in Merced County, they benefit from Tuolumne River irrigation projects. (Above, courtesy of the authors; right, courtesy of Alexander Trujillo.)

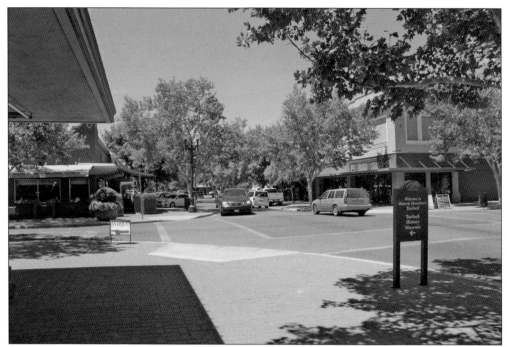

The city of Turlock, founded in 1887, was established as a shipping point along the railroad. Turlock is close to 17 square miles in size and contains approximately 10 percent of the original John Mitchell ranch. Mitchell came to California with the intention of growing wheat. He was successful and established towns on his 100,000-acre ranch. The land was used for wheat, and by 1874, California was the top producer of wheat in the country. Today, Turlock is known for California State University, Stanislaus and the annual Stanislaus County Fair. (Above, courtesy of the authors; below, courtesy of the authors.)

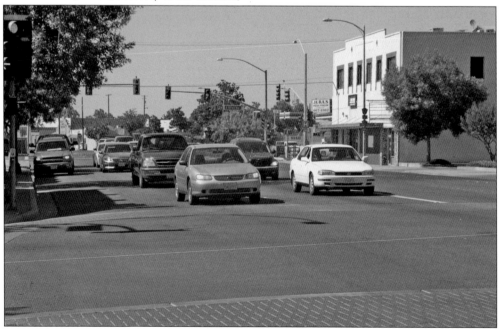

Modesto, founded in 1870, is the current seat of Stanislaus County. The town is known today for being a business hub and is recognized for its diverse culture. Modesto is home to the Gallo Center for the Arts, the Modesto Nuts minor-league baseball team, and *Star Wars* creator George Lucas. The population—now over 200,000—has been growing every decade since 1870. The image above is of downtown Modesto on J Street, and the photograph below is of McHenry Street in central Modesto. (Above, courtesy of the authors; below, courtesy of Alexander Trujillo.)

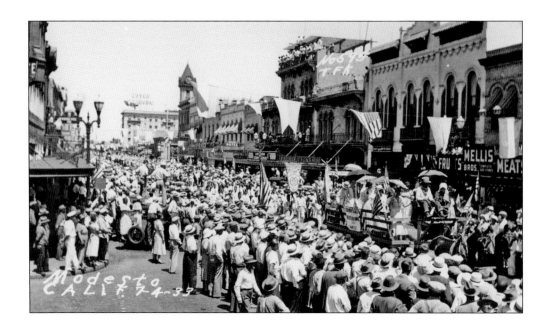

The development of Stanislaus County has been a long and rewarding journey. Nothing could have been possible without the dedicated, hardworking individuals who set out to make a new home in an untamed land. Technology, manpower, and determination were nothing without the life-giving Tuolumne River. The above image shows a July 4th celebration in Modesto in 1933, while the image below is of a Turlock Melon Carnival parade around 1912. (Above, courtesy of the McHenry Museum; below, courtesy of CSU Stanislaus Special Collections.)

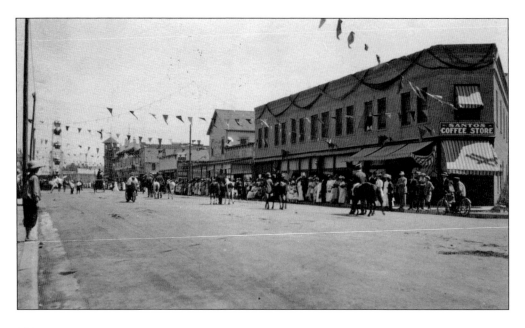

Six

RECREATION ON THE RIVER

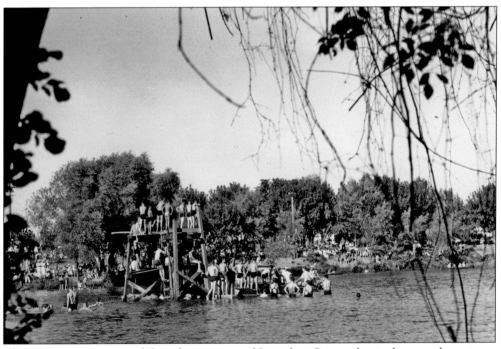

The Tuolumne River gives life to the economy of Stanislaus County, but it also provides a means for fun and relaxation. Recreation of all sorts can be enjoyed in and along the river. People from around the county make visits to absorb the beauty that is the Tuolumne River. Swimming is a popular river activity. The boys in this image are having fun on a hot summer day. (Courtesy of the McHenry Museum.)

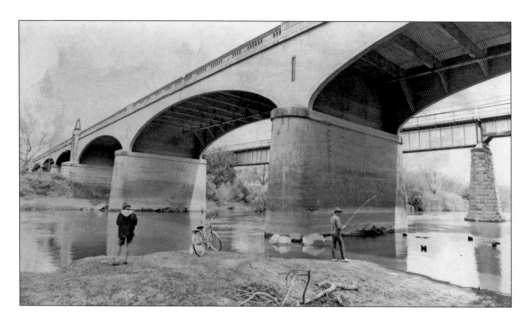

Fishing is an enjoyable pastime for young and old. This relaxing activity is free for children under the age of 16. In 2013, the California Fish and Game Commission reported selling around 26,000 residential year-round memberships for the sport of fishing. In the above image, young boys fish on the banks of the Tuolumne River. Below, a man fishes underneath one of the Modesto-Tuolumne bridges. (Both, courtesy of the McHenry Museum.)

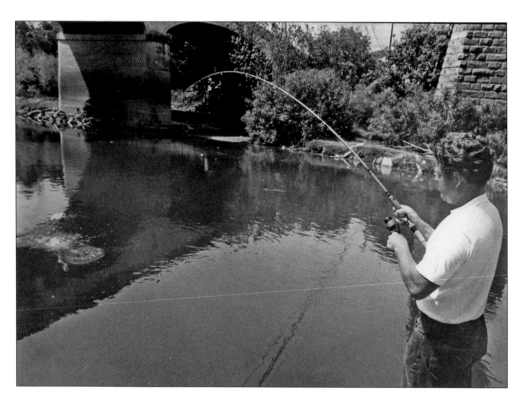

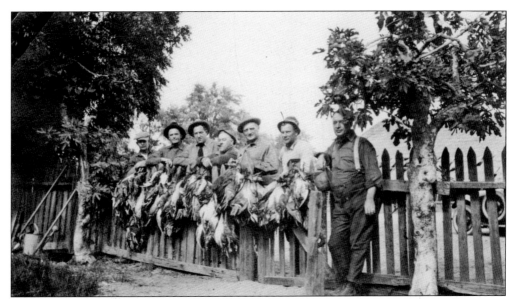

As shown in the first chapter, the river is home to a plethora of species. Many of the older generations hunted along the river. Due to river development, the natural habitats of wild game have shrunk. This has caused a decline in native species over the last 100 years. Today, it is still common to find duck hunters in blinds along the Tuolumne River. In both the above and right photographs, unidentified hunters display their takings from a successful day of duck hunting. (Above, courtesy of CSU Stanislaus Special Collections; right, courtesy of the McHenry Museum.)

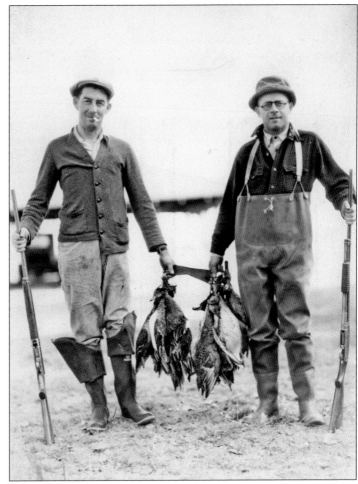

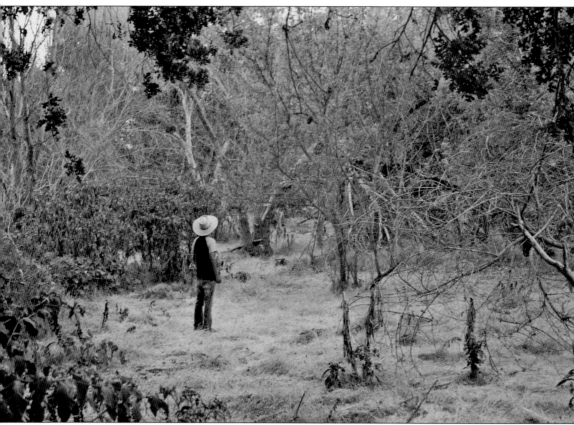

Those who prefer not to hunt or fish can bring binoculars and watch wildlife from a distance. Bird-watching allows the fragile riparian habitat to sustain its bird population. This practice can also be rewarding if one takes a camera or microphone to the river to record the wild birds. Angel Velazquez is pictured taking up his bird-watching hobby. (Courtesy of the authors.)

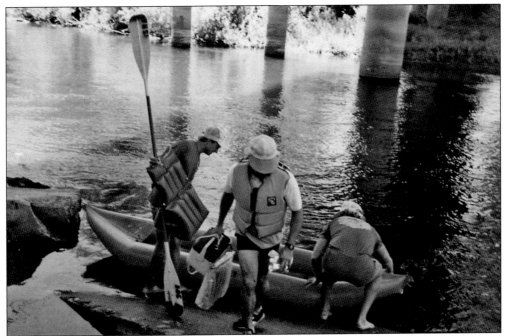

Canoeing is a great family activity available on the lower Tuolumne River. On a hot summer day, a canoe ride is a refreshing way to see parts of the river that are normally closed to the public. If a person is quiet enough on the water, a river otter or a beaver may pop out of its hiding place. In the upper portion of the Tuolumne River, canoes can be rented for the more rigorous white water. (Both, courtesy of the Great Valley Museum.)

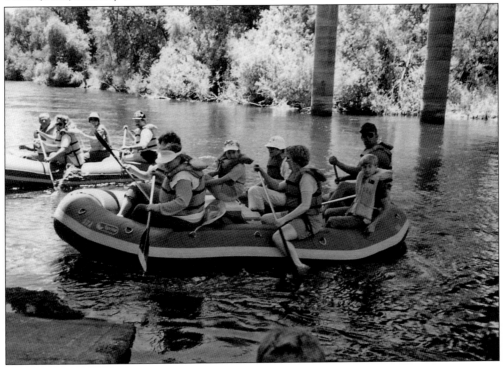

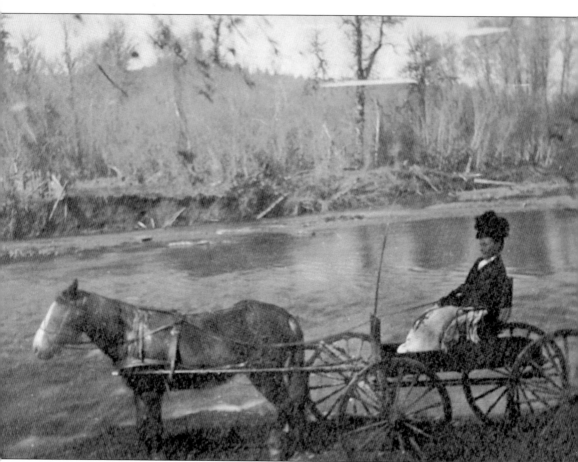

This photograph shows a woman on a horse-drawn buggy alongside the Tuolumne River. The river can be used as a distraction from the day-to-day grind. Today, visitors can still ride horses along the river. Modern thrill-seekers can ride dirt bikes in the more isolated areas along the river. (Courtesy of the Waterford Museum.)

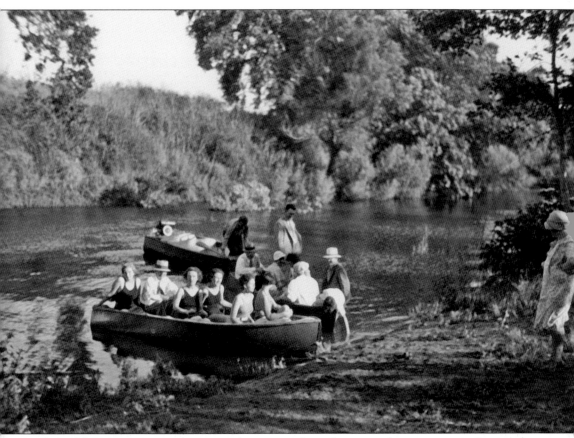

One of the most common recreational activities along the river is having a picnic. During the summer months, the parks on the river are generally filled with people. This c. 1930 image shows a group that decided to use boats to take its picnic to a more secluded area of the river. Legion Park in Modesto is well known in Stanislaus County for its largely shaded areas and beautiful scenery. (Courtesy of the McHenry Museum.)

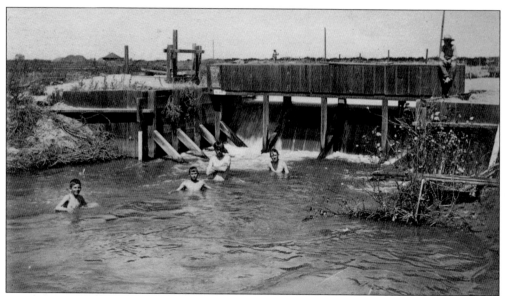

If someone were to ask a 1960 Hughson High School graduate where the best swimming place was, he or she would most likely say "the Drop." The Drop was a canal in the southern part of Hughson where teenagers would spend their summer days cooling off. Today, canals are known for being unsafe because of their steep cement walls. The architecture of newer canals allows more water to travel through them, and although they require less maintenance, they have become more dangerous. The c. 1925 image above was taken in Turlock, and the image below was taken somewhere in the outskirts of Modesto. (Above, courtesy of CSU Stanislaus Special Collections; below, courtesy of the McHenry Museum.)

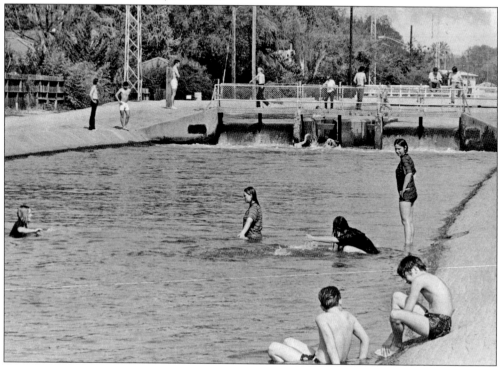

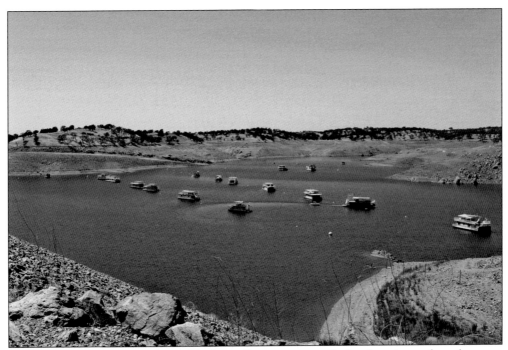

Boating is the most common form of Tuolumne River recreation. In the above image, houseboats are lined up in Lake Don Pedro. For a few thousand dollars, a houseboat can be rented for a weekend. Many boaters take a small craft to the lake to pull a skier. In the below image, boaters drive around on the Tuolumne River near south Modesto. Prior to the construction of the New Don Pedro Dam, the river flowed at a higher volume and allowed boats to be able to travel up and down the river. Today, most boats are unable to pass through the shallow areas, which are sometimes only one foot deep. (Above, courtesy of the authors; below, courtesy of the McHenry Museum.)

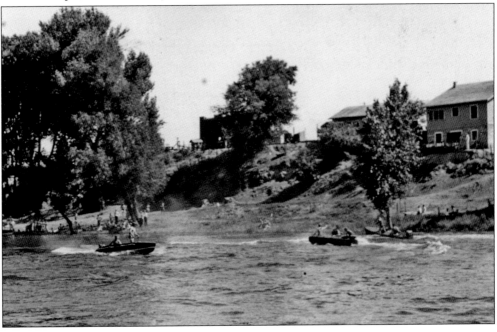

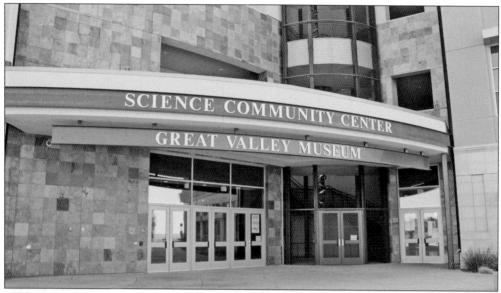

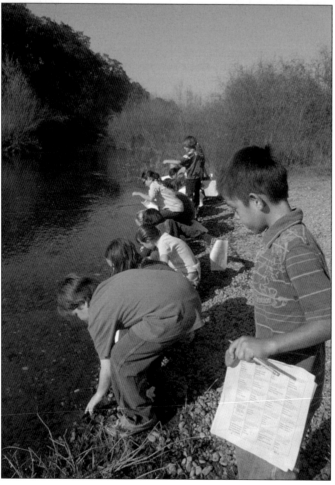

The Great Valley Museum of Natural History opened in 1980 at the corner of Stoddard and College Avenues in Modesto. The idea of opening a natural history museum at Modesto Junior College (MJC) started in the 1960s with intentions of educating the public about the local environment. Today, the Great Valley Museum is known throughout the Central Valley for its educational programs. The above photograph shows the new home of the Great Valley Museum on the West Campus of MJC, which opened in 2014. In the left image, children are learning how to become biologists. The Great Valley Museum has played an influential role in educating children about the importance of conserving the Tuolumne River. (Above, courtesy of the authors; left, courtesy of the Great Valley Museum of Natural History.)

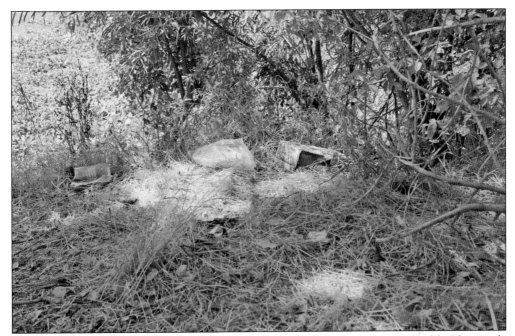

The above image demonstrates how pollution is affecting the Tuolumne River's health. The people of Stanislaus County need to realize that the only way to keep their way of life is by working to conserve the natural landscape and precious water supply. The Tuolumne River Trust (TRT) main office, pictured below, is located on Thirteenth Street in Modesto. The TRT was organized in 1981 and is an important resource for those who are interested in preserving the Tuolumne River. The community involved with TRT is well known for its efforts to clean up the river and elevate the quality of its environment. (Both, courtesy of the authors.)

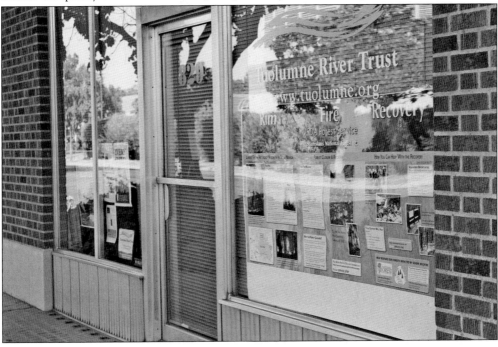

BIBLIOGRAPHY

Elias, Solomon Philip. *Stories of Stanislaus; a Collection of Stories on the History and Achievements of Stanislaus County.* Los Angeles, 1924.

Emig, Carla G. *Changing Agricultural Patterns in the Turlock Irrigation District From 1887 to 1986.* Master's thesis, California State University Stanislaus, 1986.

Garone, Phillip. *The Fall and Rise of the Wetlands of California's Great Central Valley.* Berkeley: University of California Press, 2011.

Hohenthal, Helen Alma. *Streams In A Thirsty Land.* Turlock, CA: City of Turlock, 1972.

Johnson, Stephen, Gerald Haslam, and Robert Dawson. *The Great Central Valley: California's Heartland.* Berkeley: University of California Press, 1993.

Martin, Ben R. *The Hetch Hetchy Controversy: The Value of Nature in a Technological Society.* Master's thesis, Brandeis University, 1981.

Paterson, Alan M. *Land, Water and Power: A History of the Turlock Irrigation District 1887 to 1987.* Glendale, CA: Arthur H. Clark Company, 1987.

Rawls, James and Walton Bean. *California: An Interpretive History.* New York: McGraw-Hill, 2011.

Righter, Robert W. *The Battle Over Hetch Hetchy: America's Most Controversial Dam and the Birth of Modern Environmentalism.* New York: Oxford University Press, 2005.

Simpson, John Warfield. *Dam: Water, Politics, and Preservation in Hetch Hetchy and Yosemite National Park.* New York: Pantheon Books, 2005.

Smith, Wallace and William Secrest. *Garden of the Sun: A History of the San Joaquin Valley, 1772–1939.* Fresno, CA: Craven Street Books, 2004.

Williams, John C., and Howard C. Monroe. *Natural History of Northern California.* Dubuque, IA: Kendal/Hall Pub., 1976.

Wurm, Ted. *Hetch Hetchy and its Dam Railroad.* Berkeley, CA: Howell-North Books, 1973.